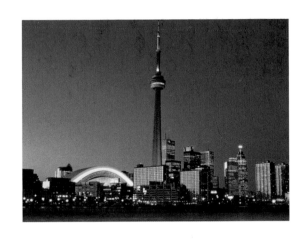

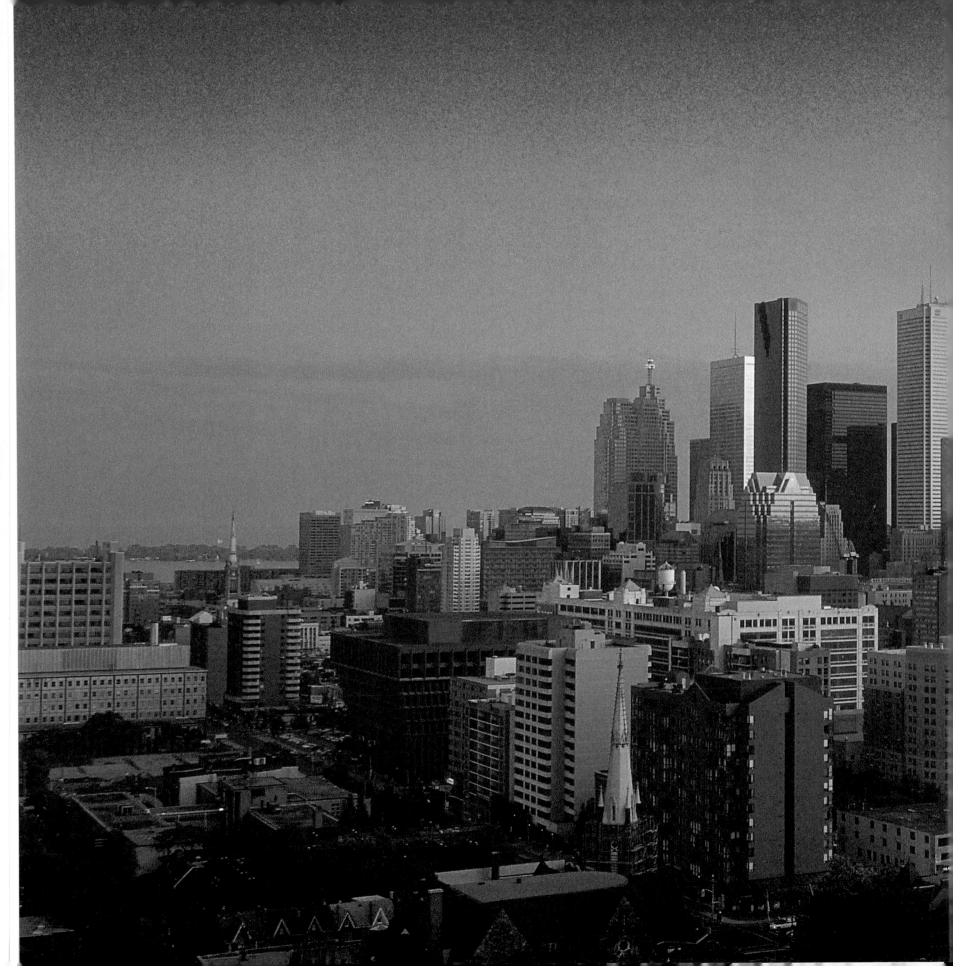

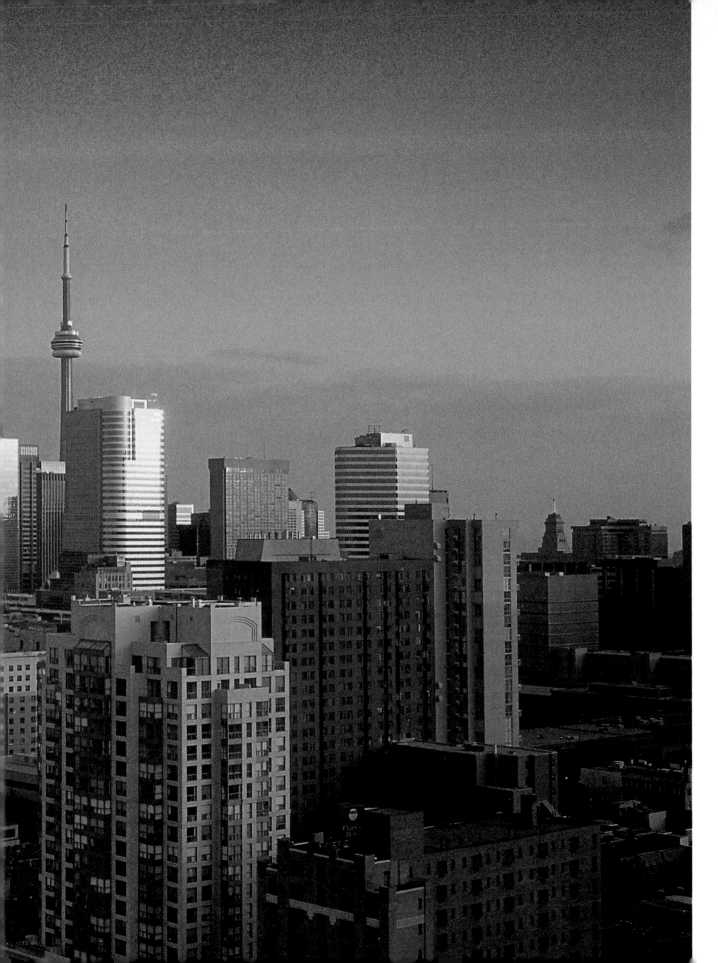

Downtown Toronto is a flourishing centre of Canadian culture and commerce. In the background, CN Tower reaches to 553 metres high. Primarily a communications tower, it is the tallest free-standing structure in the world.

7

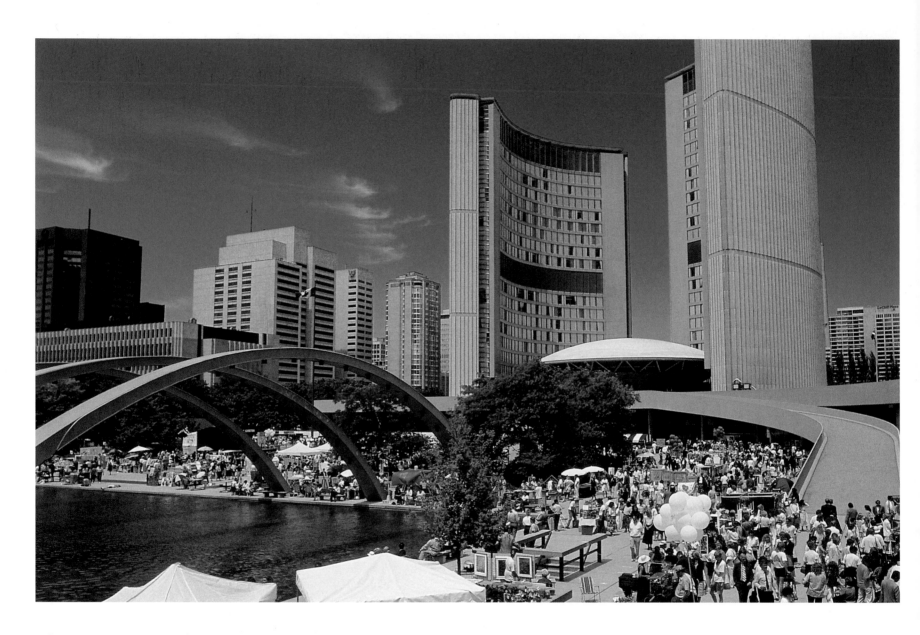

After an international competition, Toronto selected the design of Finnish architect Viljo Revell for the new City Hall, built in 1965. City Hall includes the spaceship-shaped council chambers flanked by two office towers. From the air, it looks like an eye with two eyelids.

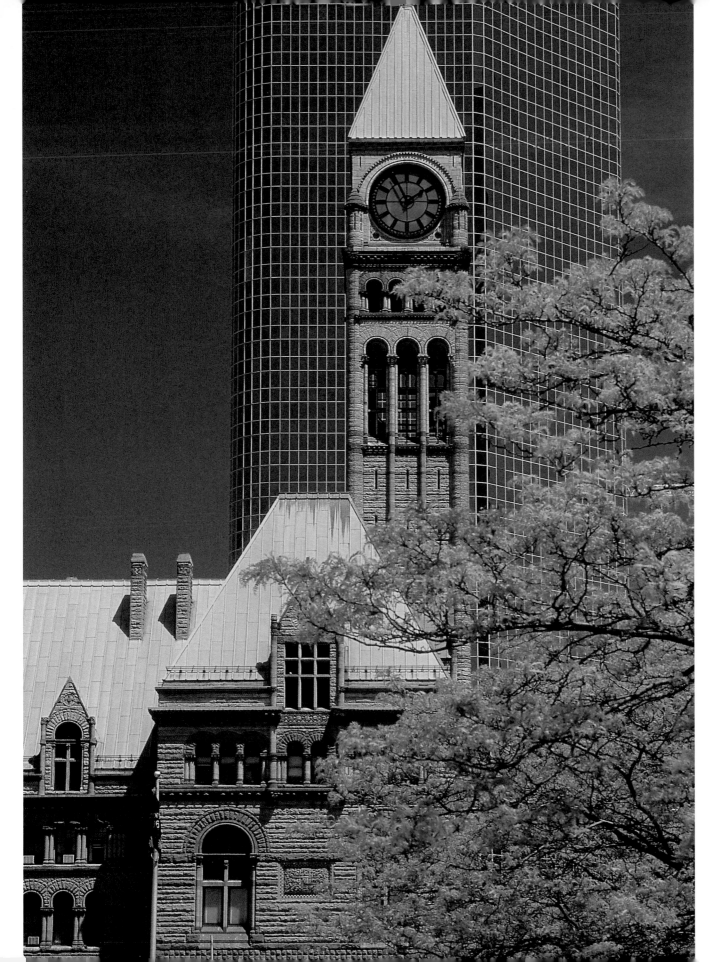

Opened in 1899, the old City Hall houses wood floors from Georgia, sandstone from the Credit River Valley, greystone from the Orangeville area, and brownstone from New Brunswick. The city's coat of arms is stamped into the building's doorknobs.

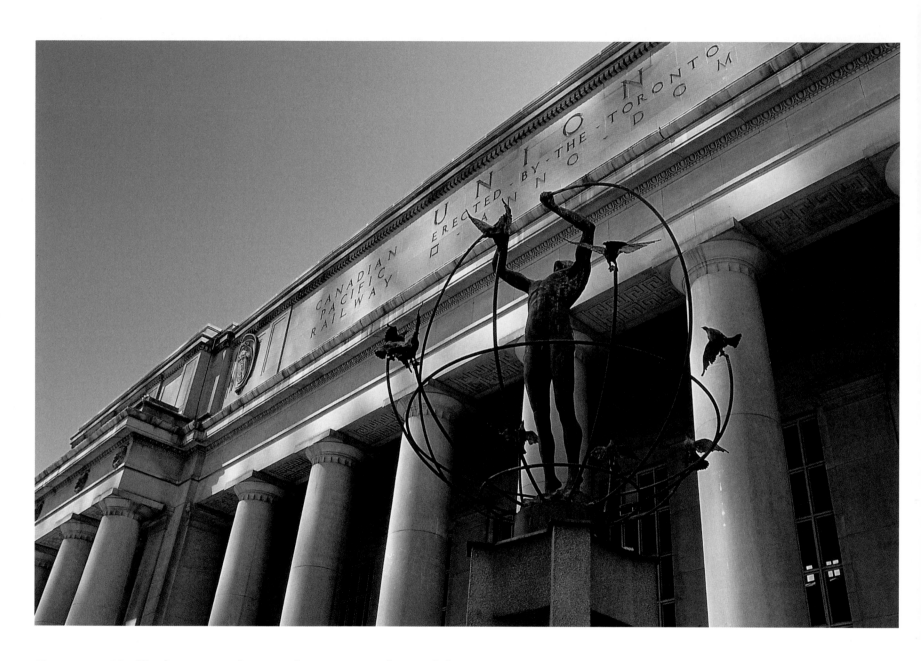

Francesco Pirelli's bronze sculpture of a person within a globe is called Monument to Multiculturalism. It was commissioned by the National Congress of Italian Canadians in honour of the city's 150th anniversary. The massive limestone columns of Union Station stand behind—each column weighs 68.5 tonnes.

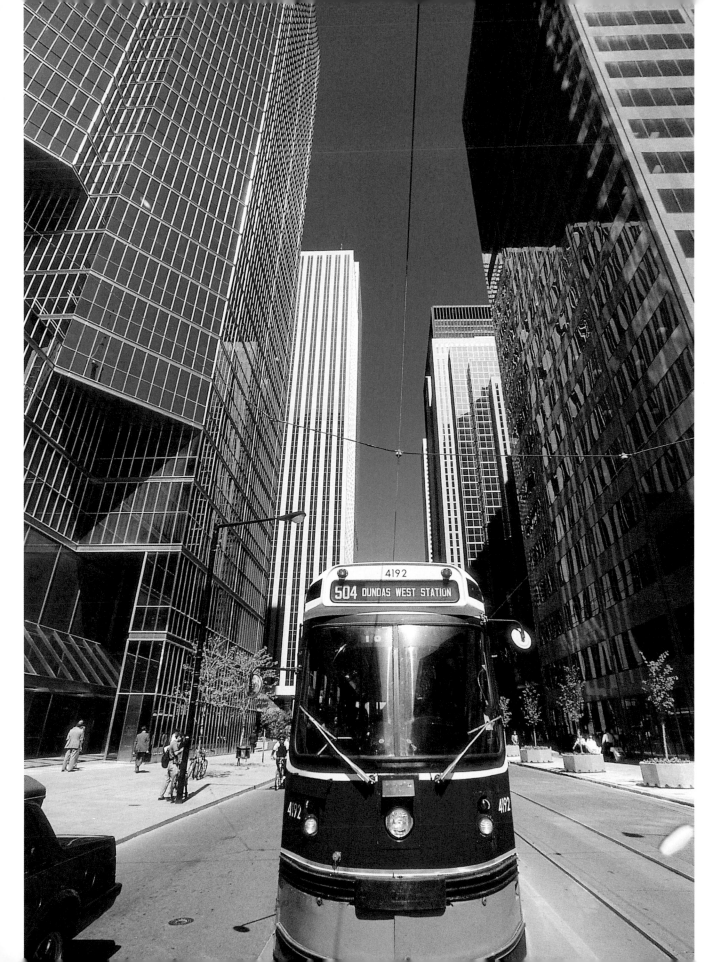

Stagecoach service began in Old York in 1828. Public transportation has come a long way since then, with many commuters travelling daily on the buses, subway, and streetcars such as this.

11

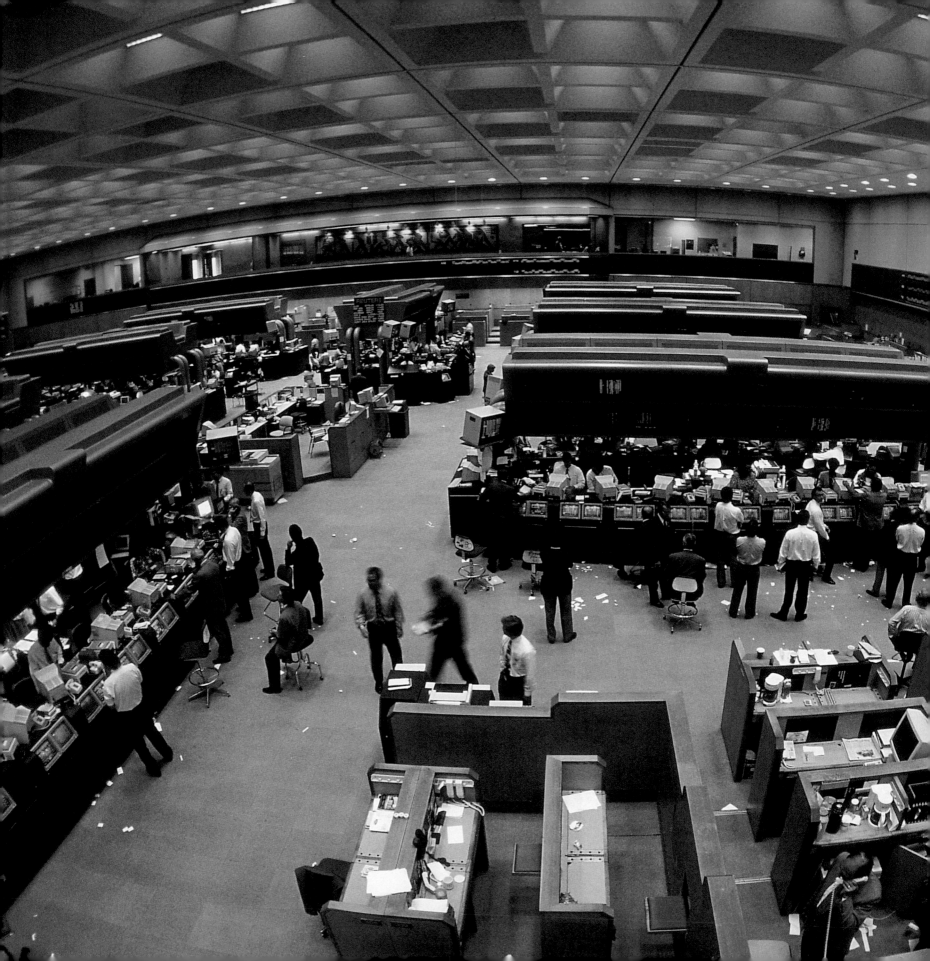

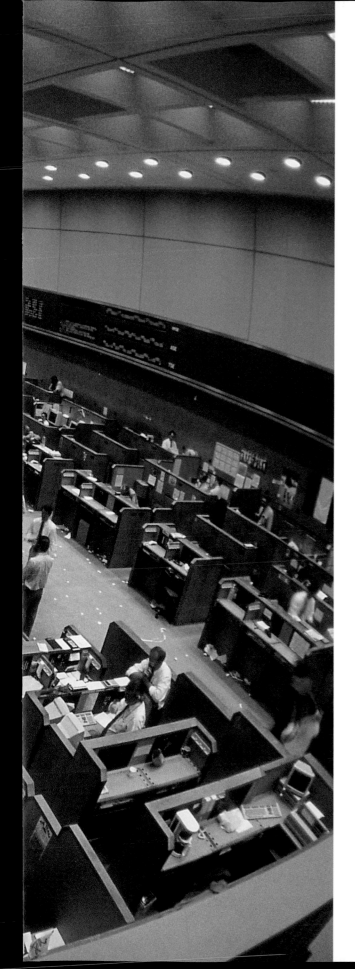

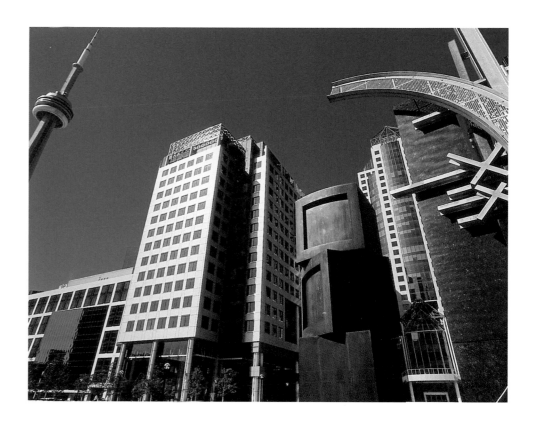

The office building in the centre of this picture is Metro Hall, which houses the Metro Toronto level of government, a co-operation of the six municipalities within the metropolitan region. The building to the left houses the Canadian Broadcasting Corporation.

The high-tech Toronto Stock Exchange is Canada's largest public market-place. Traders buy and sell stocks in companies ranging from Air Canada to Rogers Communications.

Both the interior and exterior of the Ontario Parliament Buildings are known for their intricately carved detail.

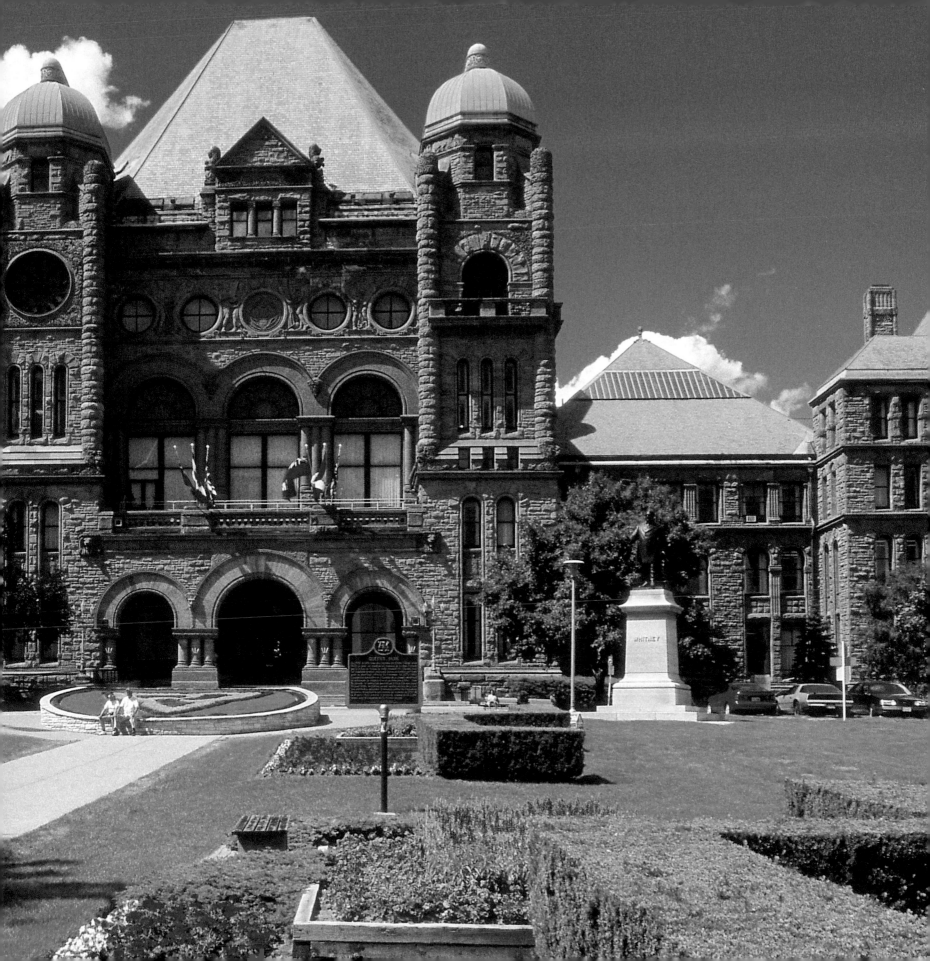

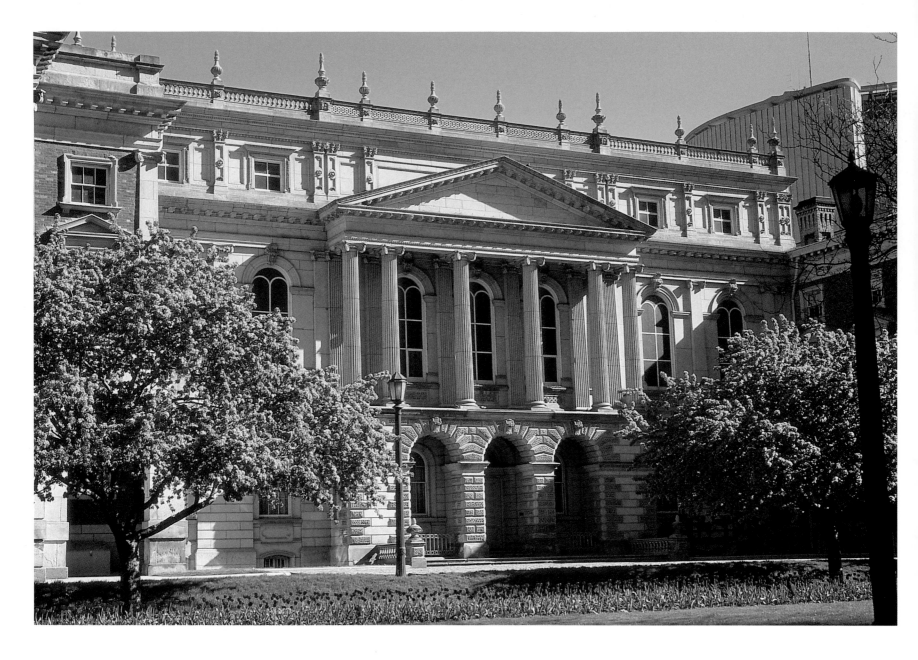

Osgoode Hall, named for the province's first chief justice, is the home of the Law Society of Upper Canada and the Supreme Court of Ontario. Although the building is now surrounded by city bustle, when it was built in the 1800s an iron fence had to be erected to keep cattle from wandering onto the grounds.

With near-perfect acoustics, Toronto's original concert hall has hosted everything from classical performances to sports events. Some memorable speakers have also used the venue, including Sir Winston Churchill.

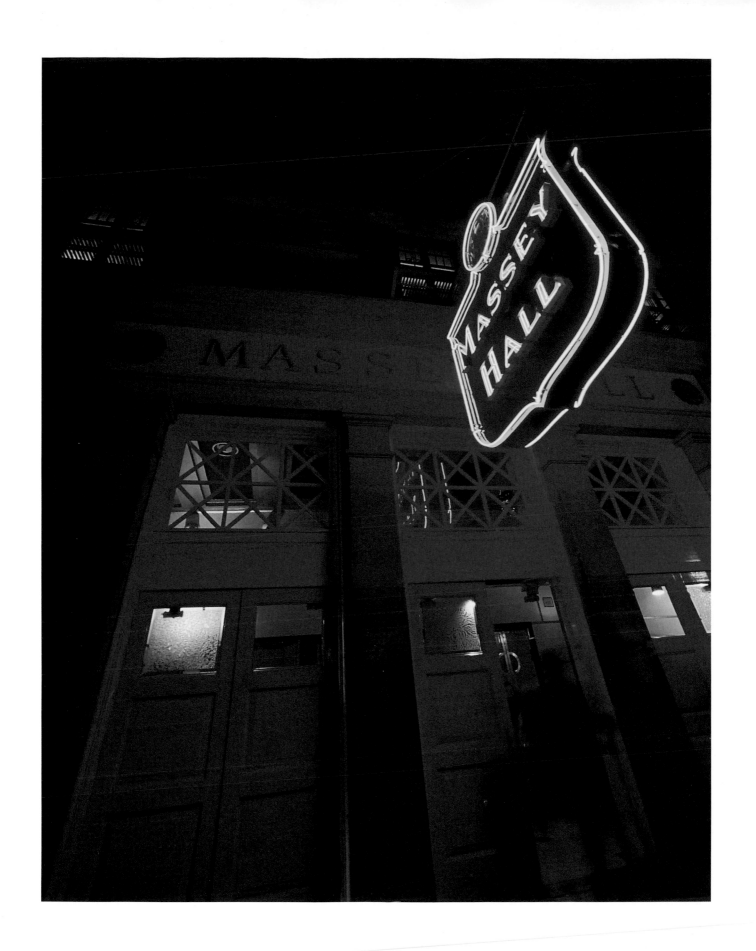

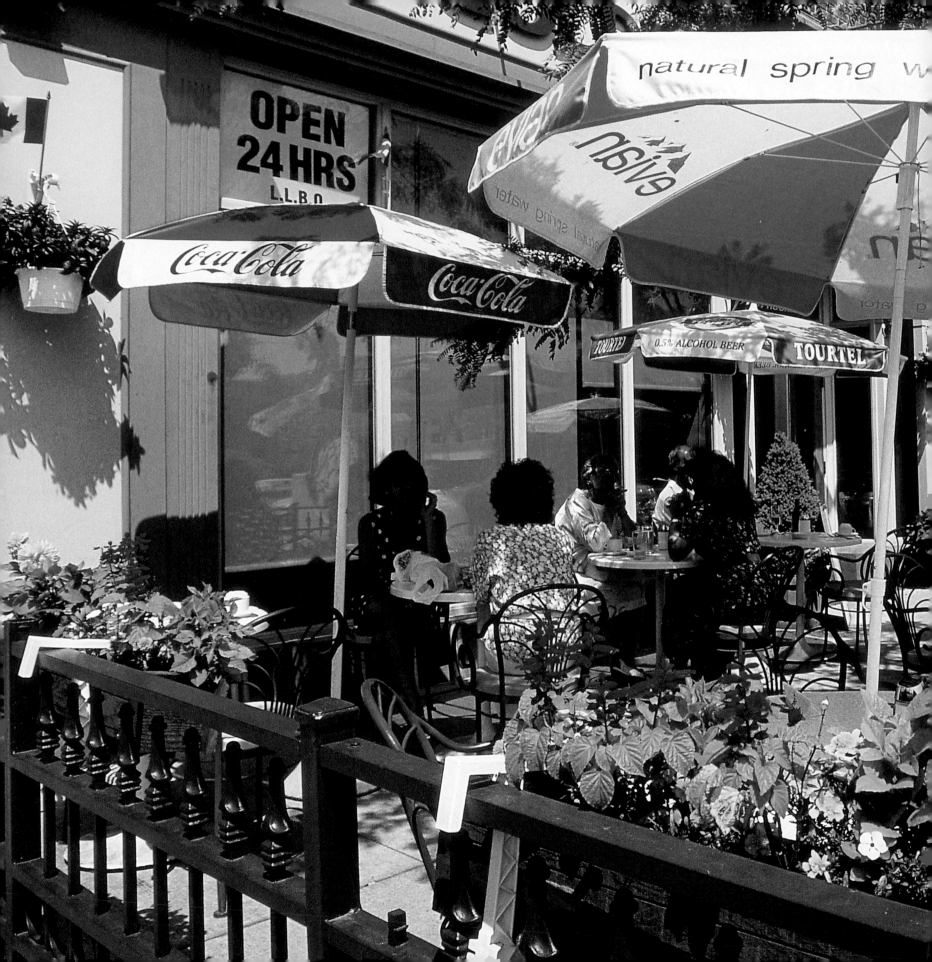

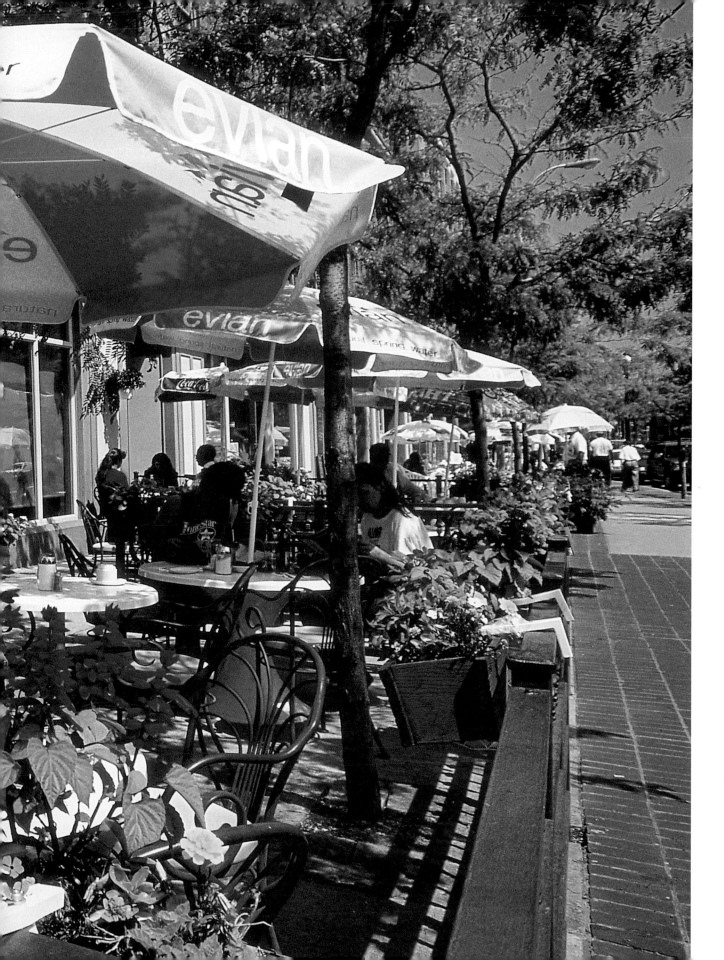

A restaurant along Front Street spills outside to accommodate the summer rush.

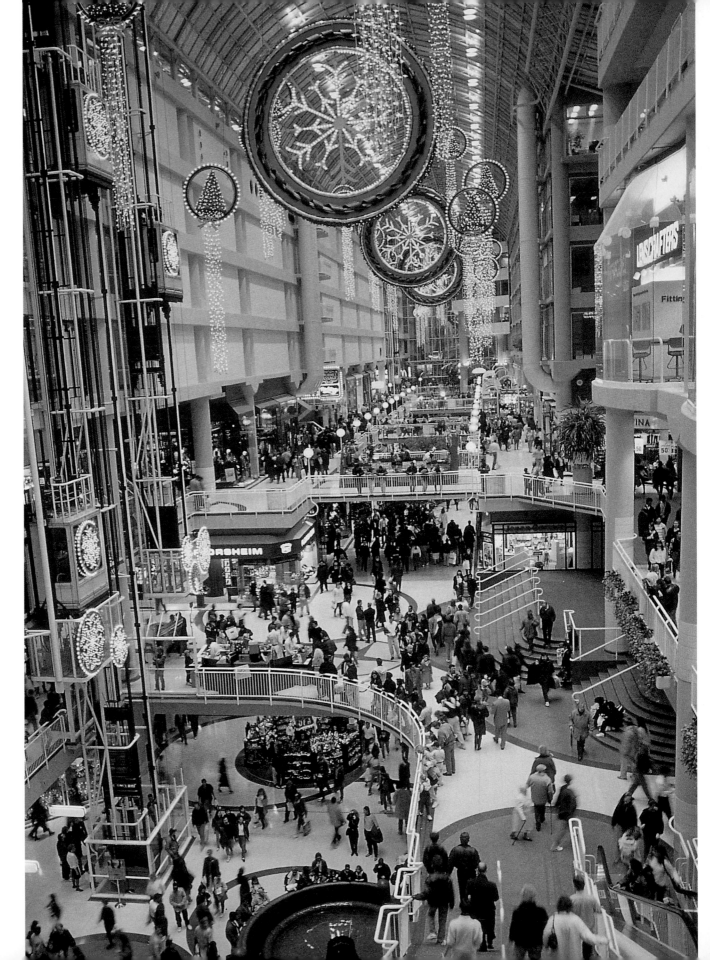

Christmas shoppers swarm through Eaton Centre, a retail metropolis with more than 300 shops and services. Visitors can see the statue of Timothy Eaton, founder of the department store chain, inside the Dundas Street entrance.

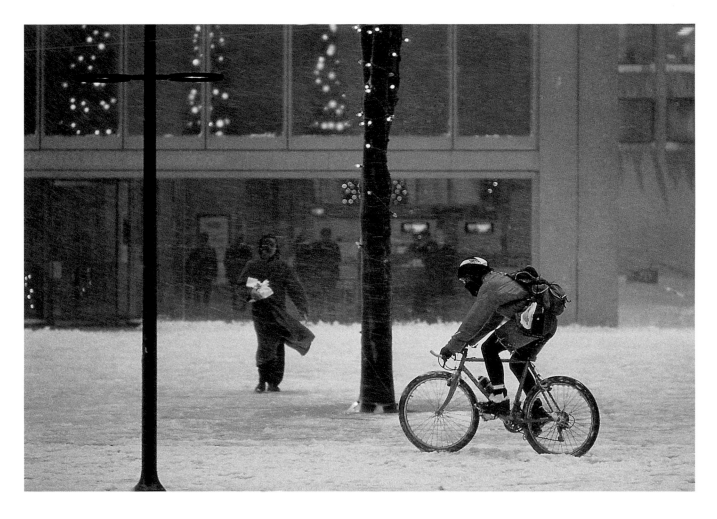

Sixty kilometres of bike trails make Toronto ideal for cycling, but the sport is more enjoyable in summer.

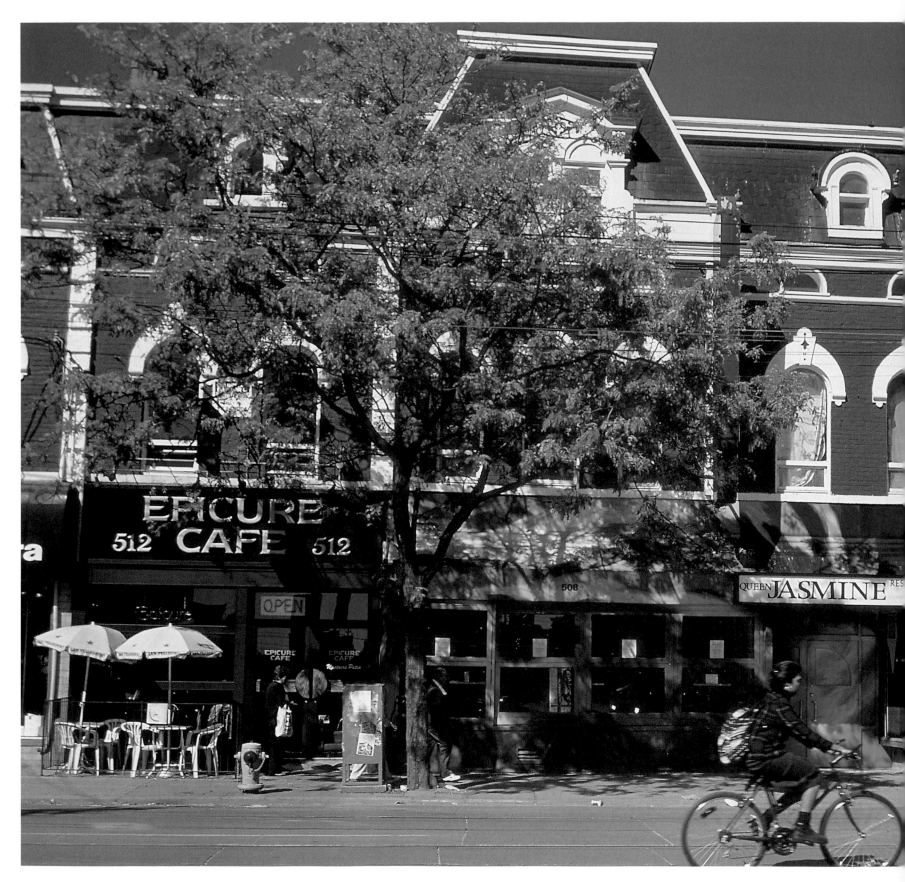

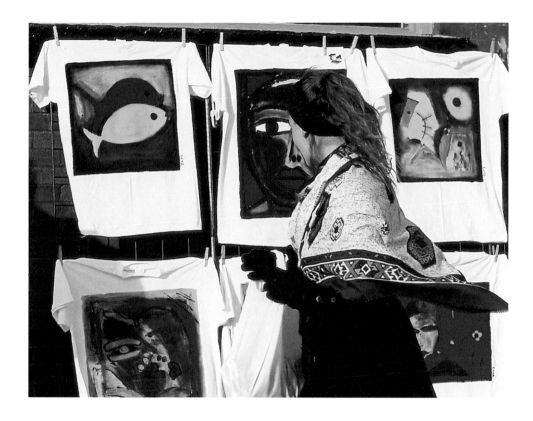

Afternoons and weekends often find vendors displaying unique wares along the sidewalks of Queen Street West.

Queen Street West combines historic storefronts with cafés, private art galleries, and specialty shops, including the largest comic-book store in North America. The Ontario College of Art is located nearby.

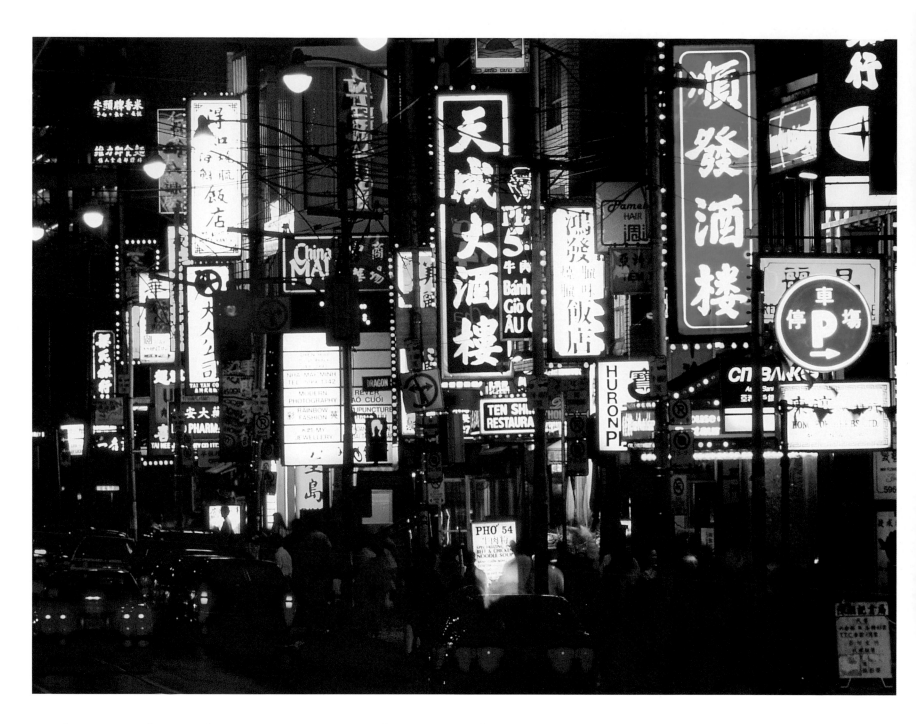

North America's largest Chinatown caters to more than 100,000 Chinese Canadians. The streets are lined with restaurants, herbalists, and bakeries, and some banks offer a choice of an electronic calculator or an abacus.

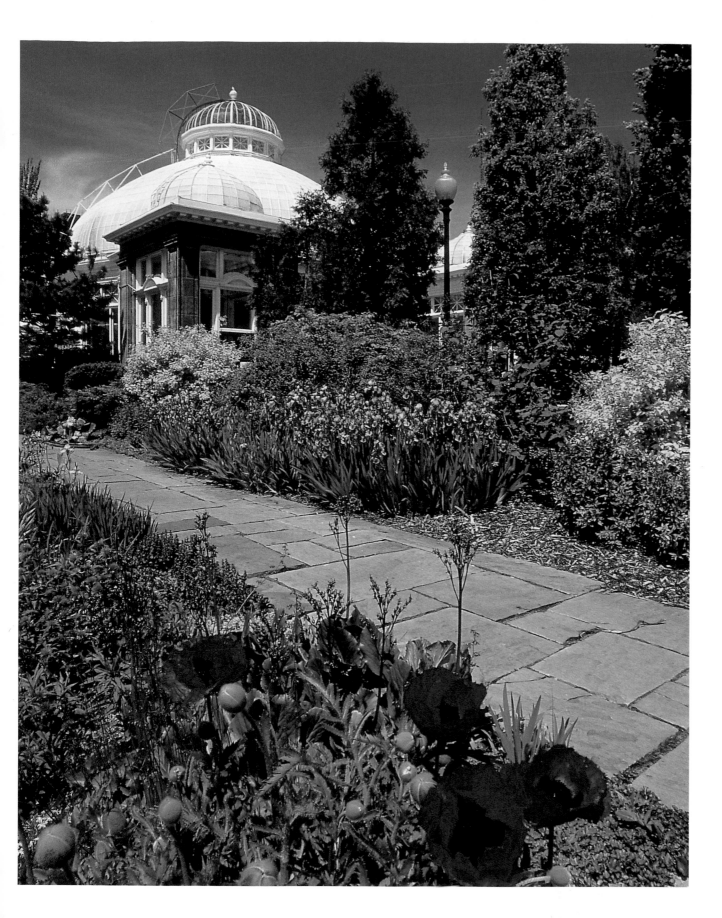

The domed green-house at Allan Gardens shelters a year-round array of tropical plants, including palms, flowering trees, and an extensive cactus collection.

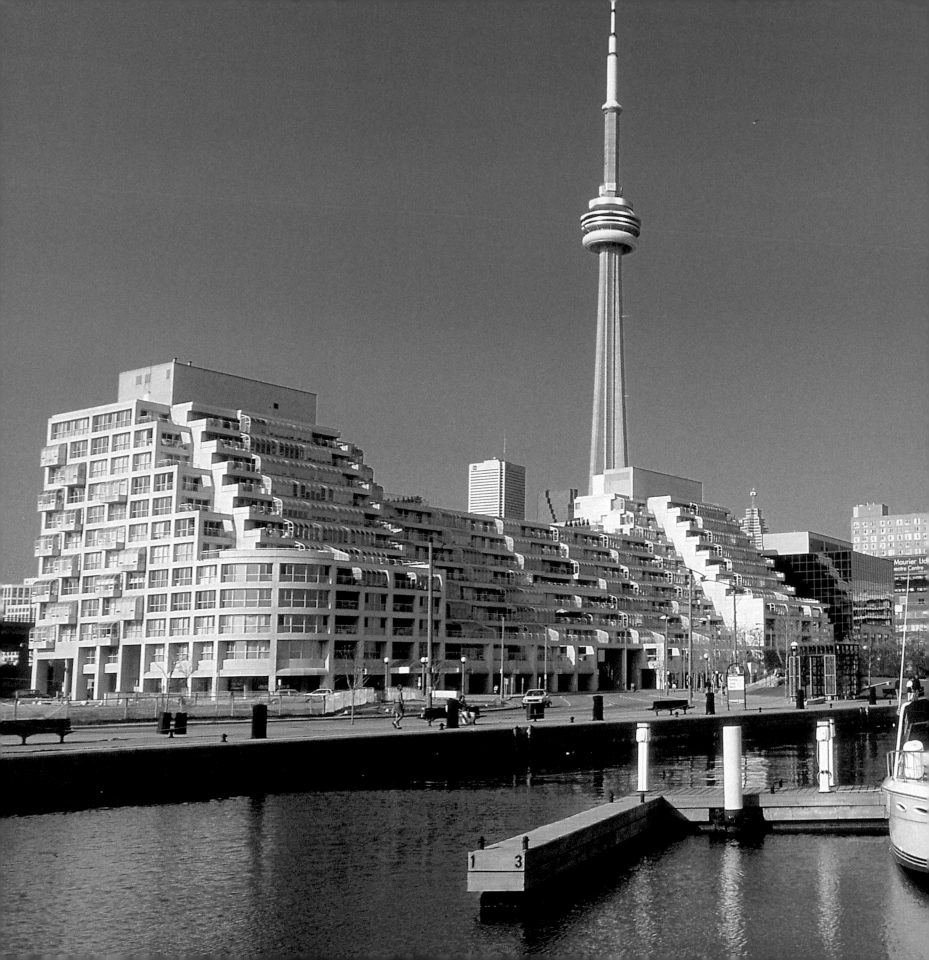

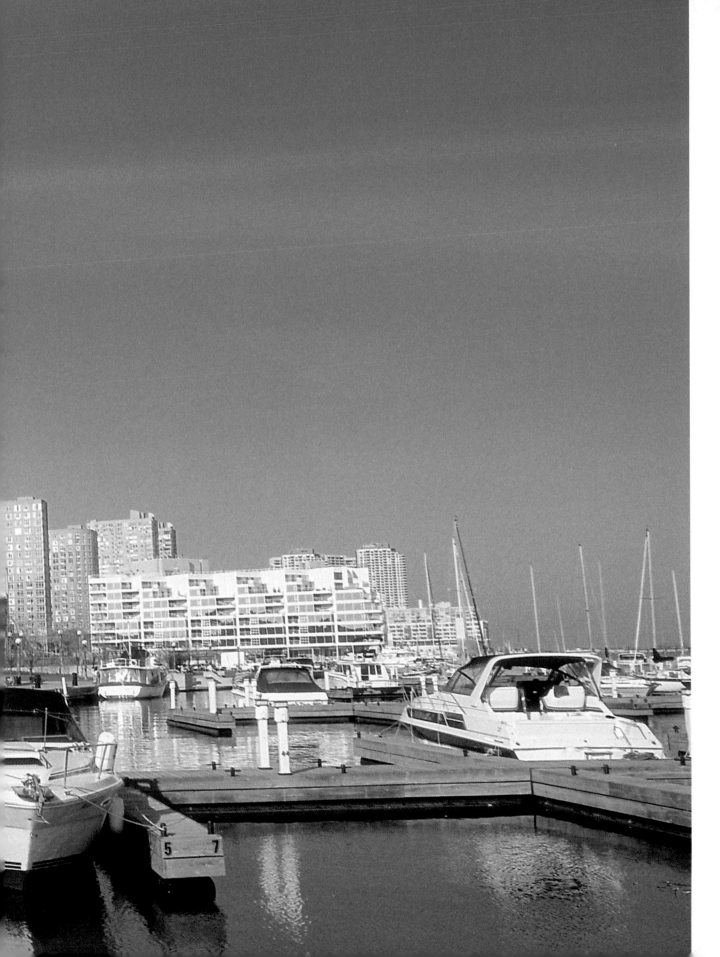

Once a run-down assortment of docks and warehouses, Harbourfront now hosts live dance, theatre, art shows, festivals, markets, and literary readings. The massive cultural and recreation centre includes playgrounds, a skating rink, and boutiques, many of which carry unique Canadian-made products.

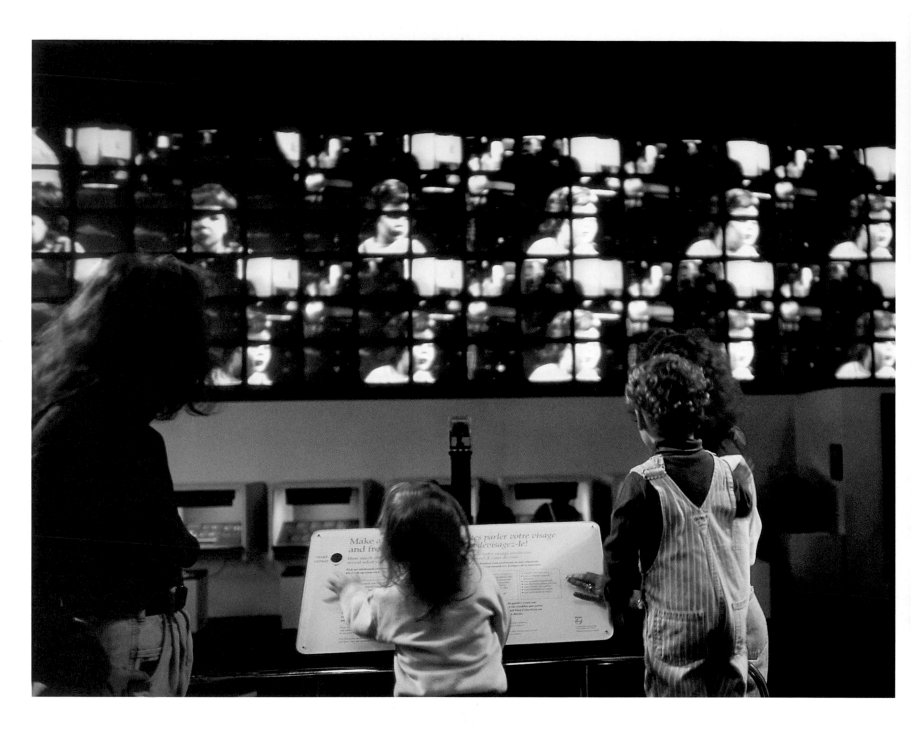

More than 800 displays in the Ontario Science Centre give children
and adults a chance to learn hands-on about everything from fitness
and nutrition to space-age technology.

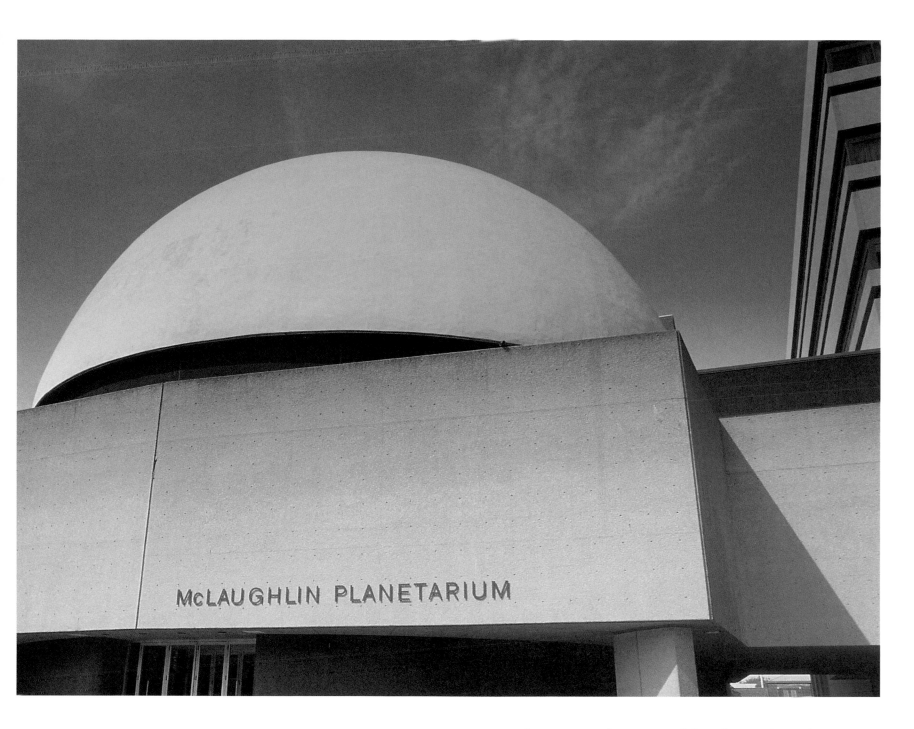

A telescope at the McLaughlin Planetarium shows visitors sun flares in action. The centre also offers slide shows, exhibits, and evening laser displays.

Housed in Toronto's first city hall, the upscale St. Lawrence Market offers high-quality seafood and produce as well as a weekend antique and flea market.

Canada No 1
Vista Bella
Apples
$2.50 per +L
Crisp + juicy

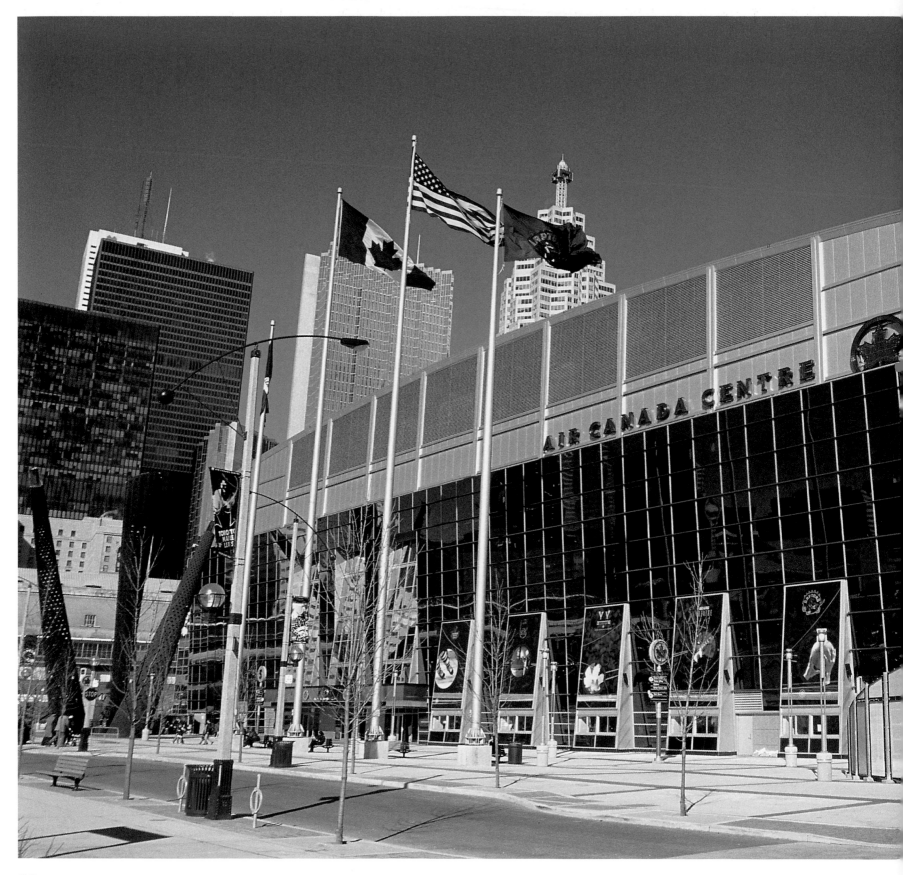

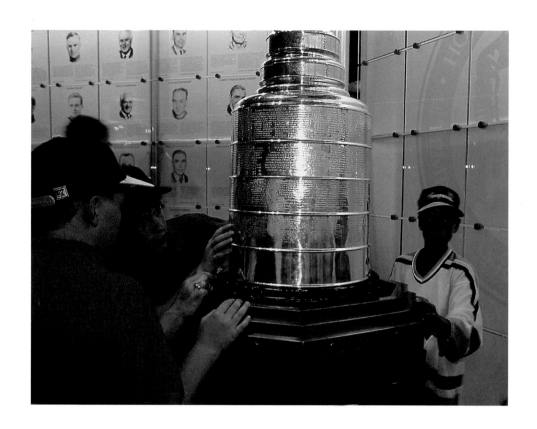

Hockey fans finger the Stanley Cup, the sport's highest honour, at the Hockey Hall of Fame. Housed in the old Bank of Montreal building, built in 1885, the hall boasts the world's largest collection of hockey artifacts.

Home of the Toronto Maple Leafs hockey team and the Raptors basketball team, the Air Canada Centre replaced Maple Leaf Gardens as the city's most popular sports venue in 1998.

Eccentric financier Sir Henry Pellatt built the 98-room Casa Loma between 1911 and 1914. He imported materials and workers from around the world, including Scottish stonemasons to build the walls surrounding the castle. It has been a tourist attraction since 1937, after a turn of fortune forced Pellatt to leave.

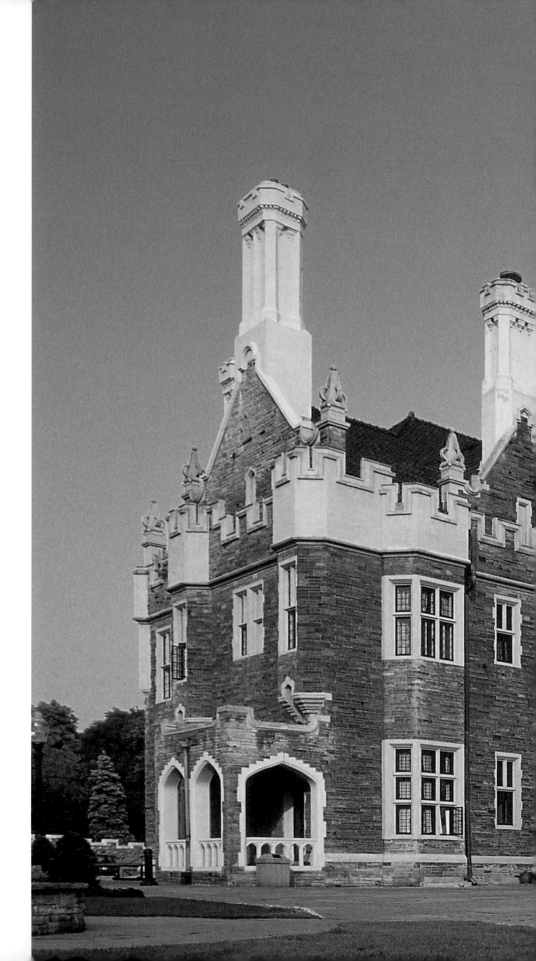

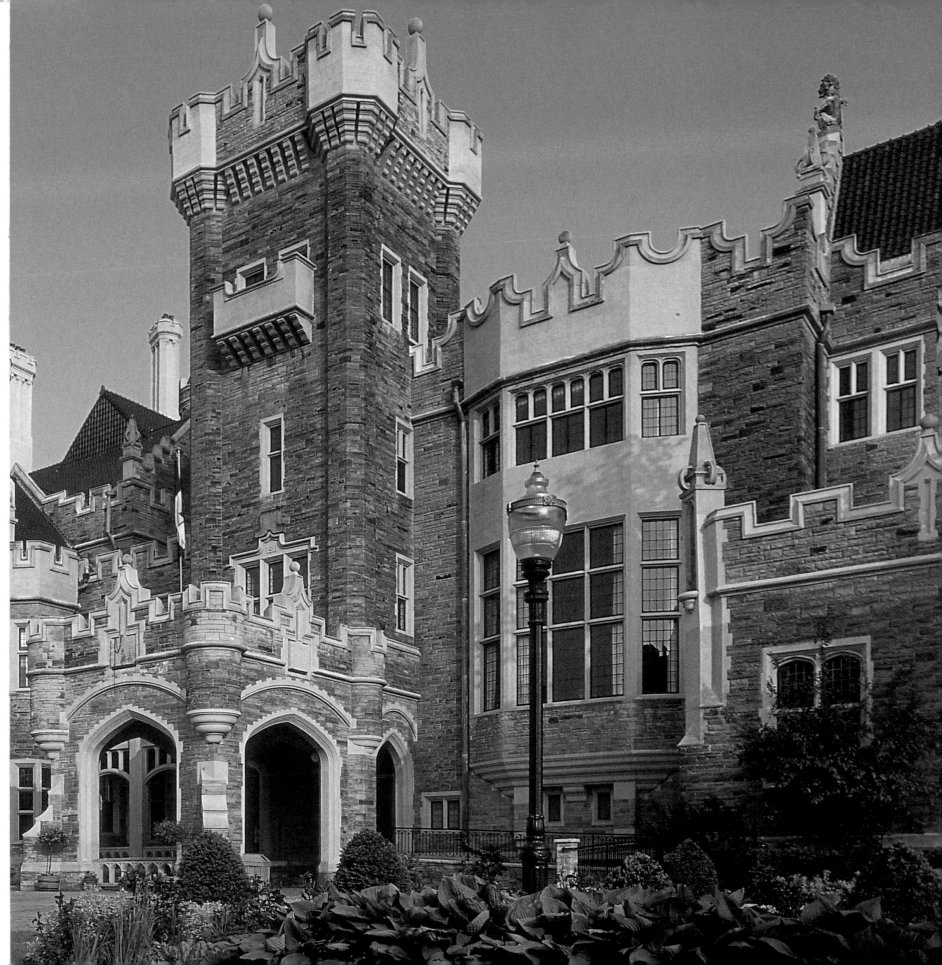

Toronto's High Park in the west end of the city includes a swimming pool, a small lake, natural forest, flower gardens, tennis courts, and a playing field. In the summer, visitors can enjoy Shakespeare performances beneath the stars.

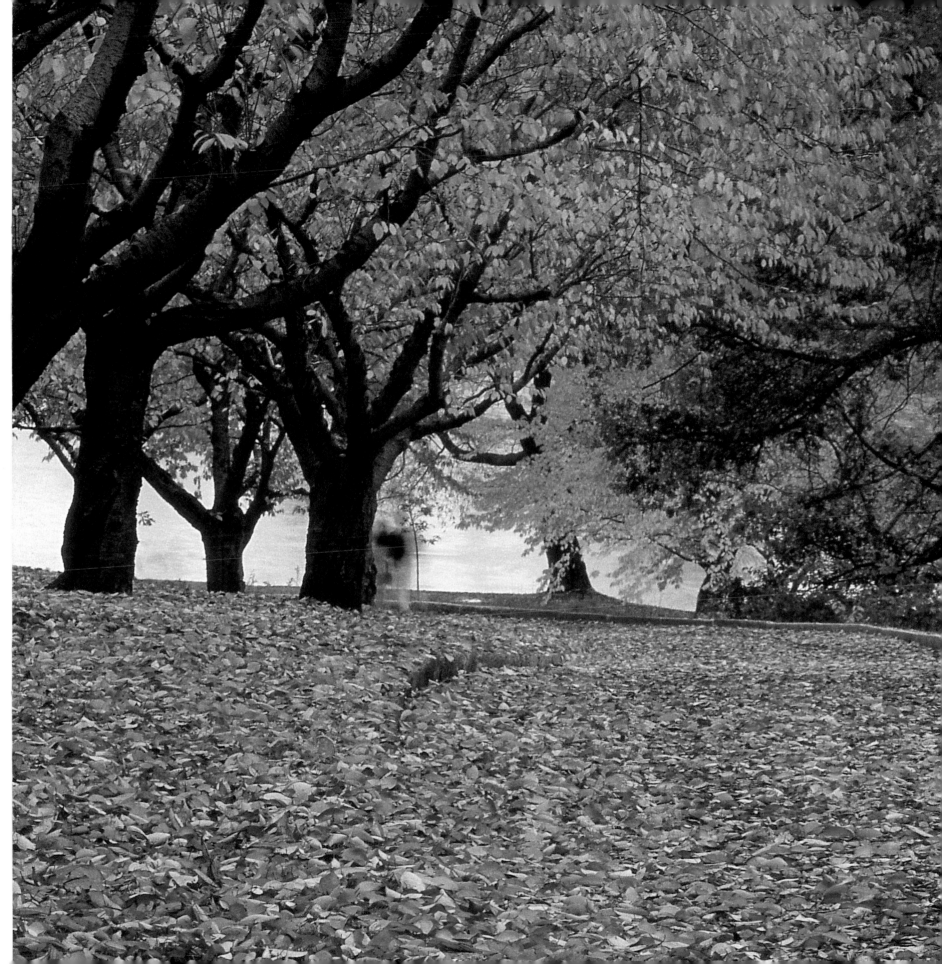

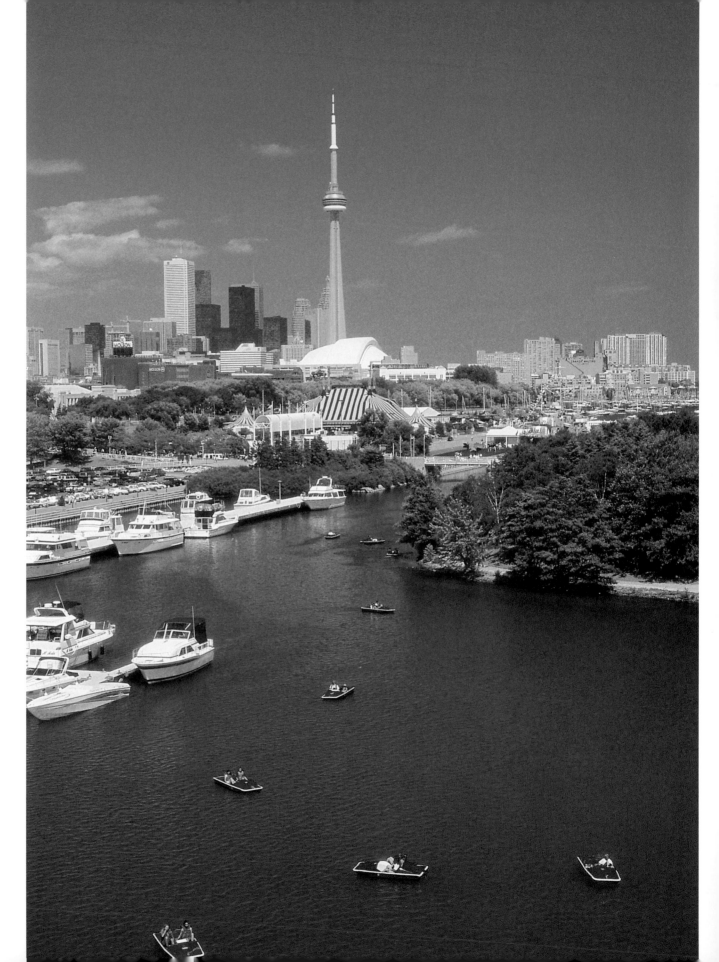

From paddle-boating to yachting, marinas along the shore of Lake Ontario offer a range of recreation opportunities. With 2000 hours of sunshine annually, Torontonians have plenty of time to enjoy the water.

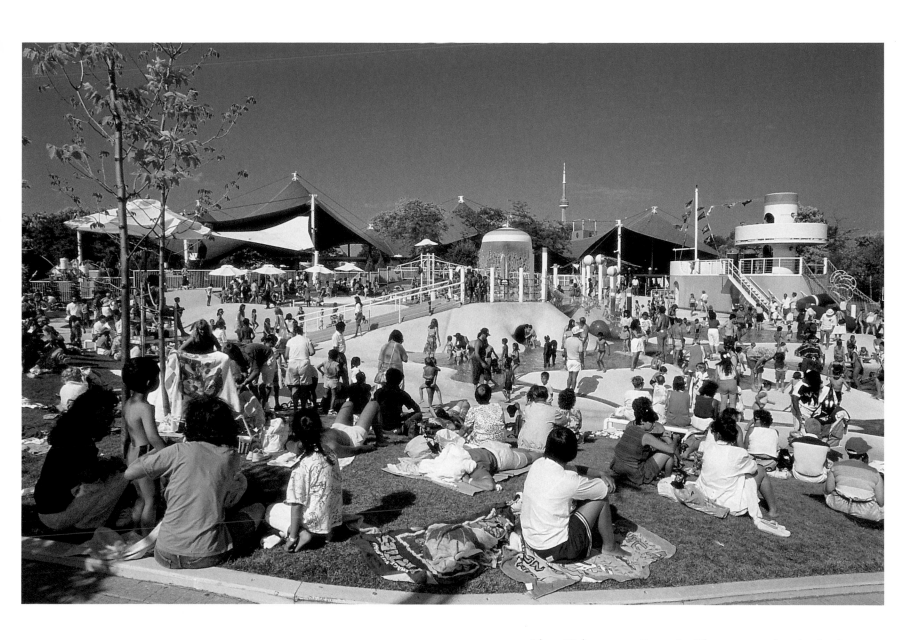

The 40-hectare Ontario Place complex includes an IMAX cinema, a concert stage, restaurants, pubs, a water park, and a playground.

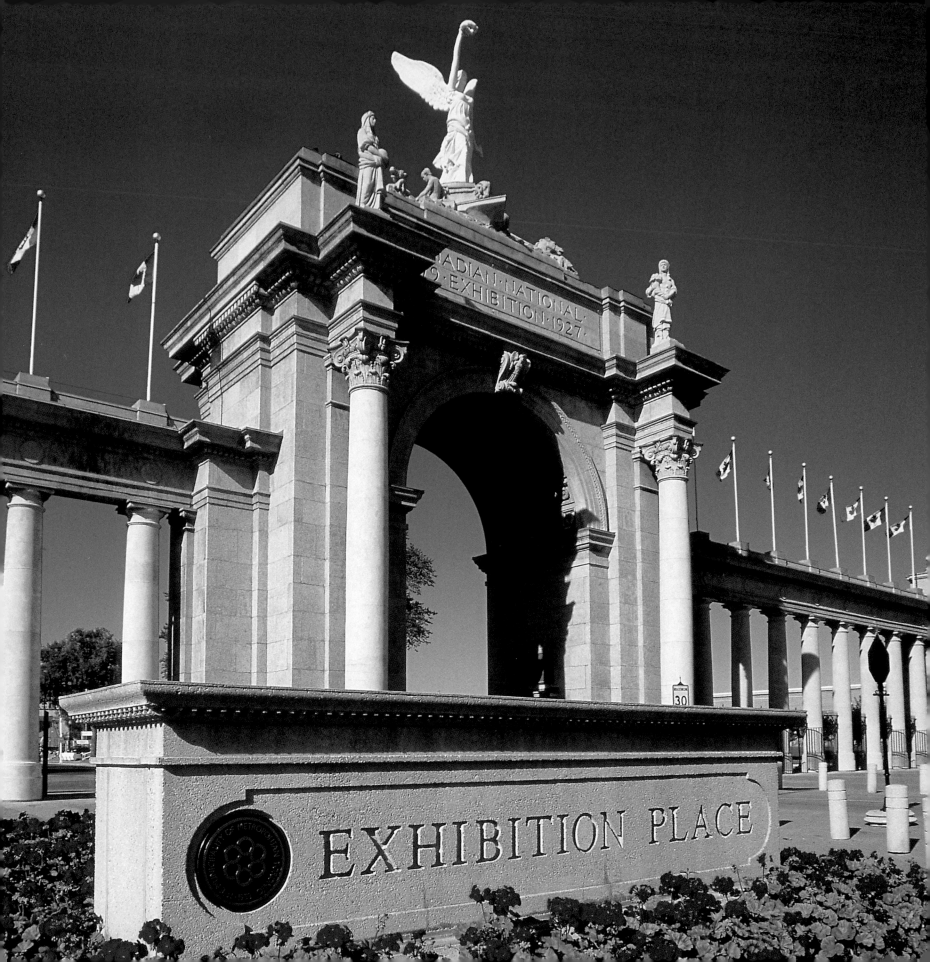

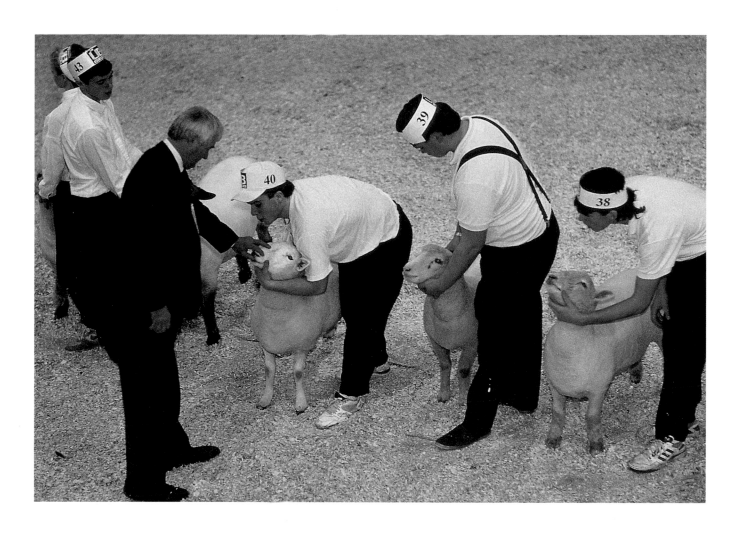

Entrants display their sheep for a judge in the Royal Agricultural Winter Fair, the world's largest agricultural fair under one roof.

Near the waterfront, Princes' Gate is the entrance to the Canadian National Exhibition, the longest-running fair in the world. Another hot attraction on site is the Molson Indy auto race, held each July.

There are half a million Italian immigrants living in Toronto—
the largest Italian community outside Italy. The first large groups
came from Italy between 1885 and 1924 to work for the railways,
mines, and factories.

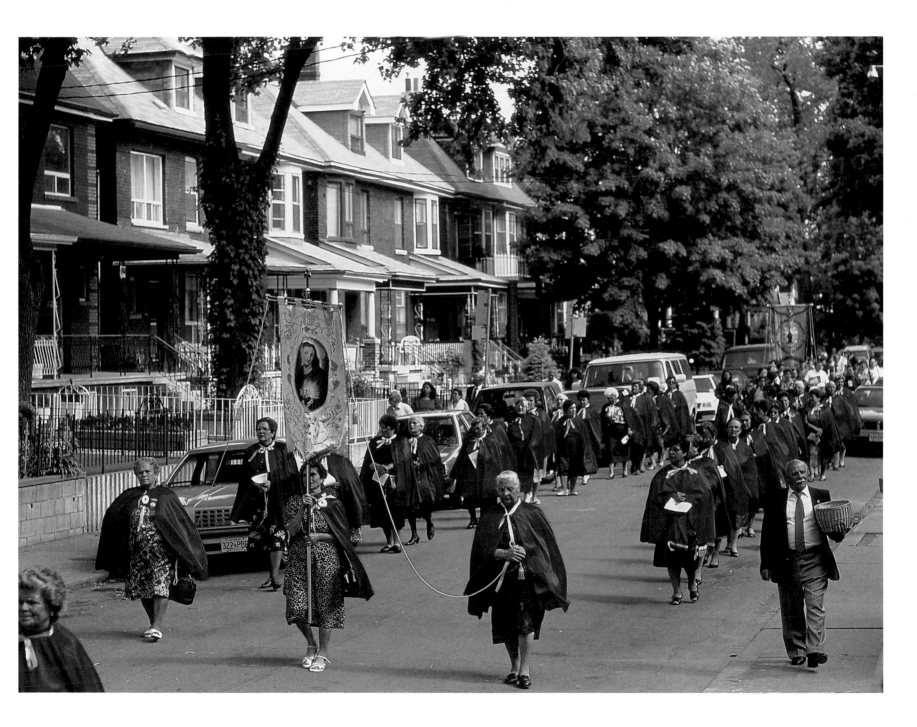

Italian Canadians celebrate July 2, the day when Italy voted to form a republic at the end of World War II.

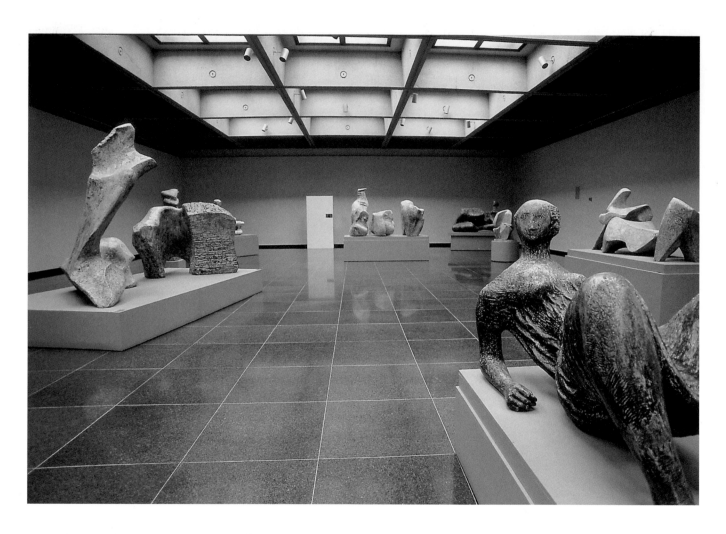

Best known for its extensive collection of works by
English sculptor Henry Moore, the Art Gallery of
Ontario also displays three centuries of Canadian art.

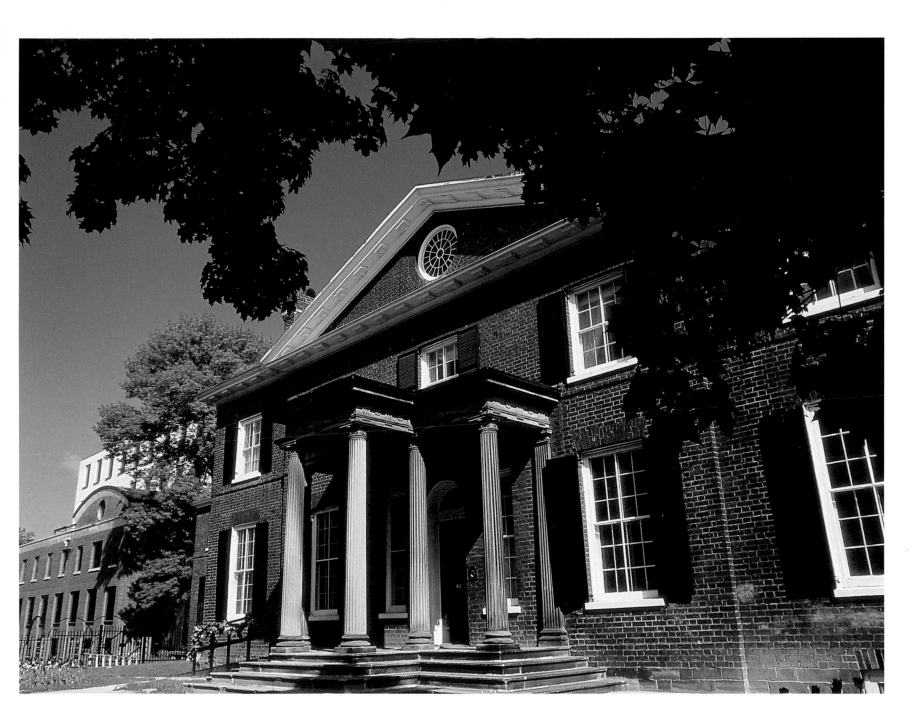

Toronto's oldest brick building, the Grange, was built in 1817 for the wealthy Boulton family and later housed the Art Gallery of Ontario. It now displays 1930s furnishings and decor.

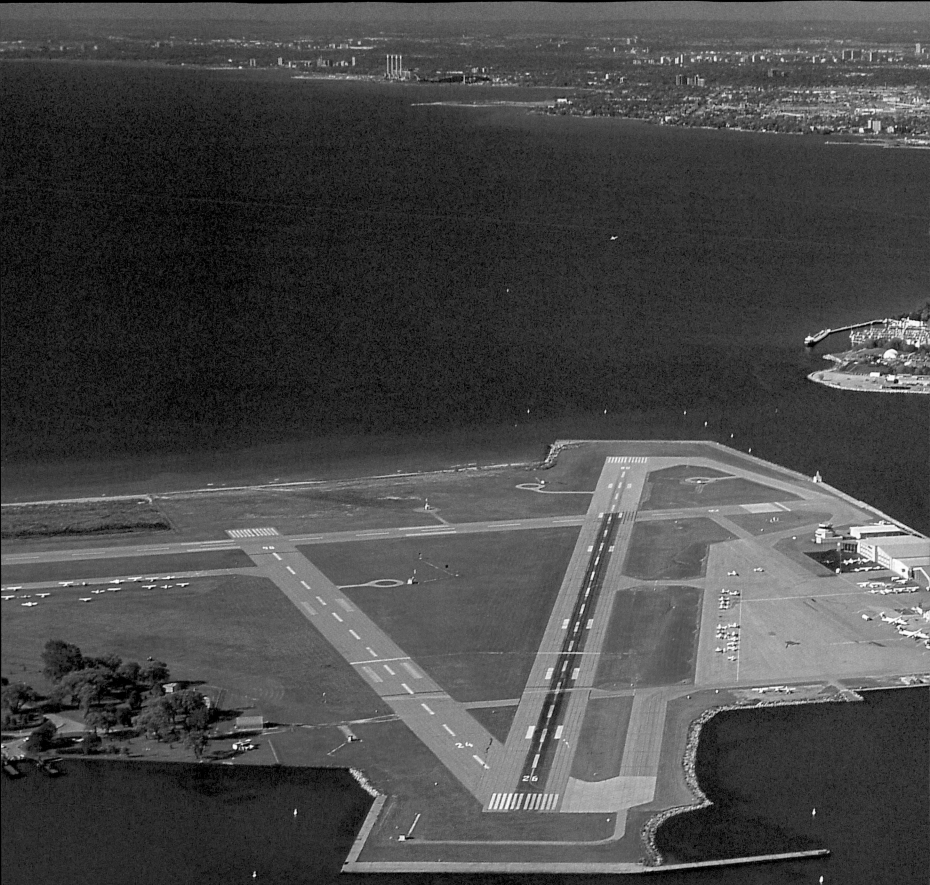

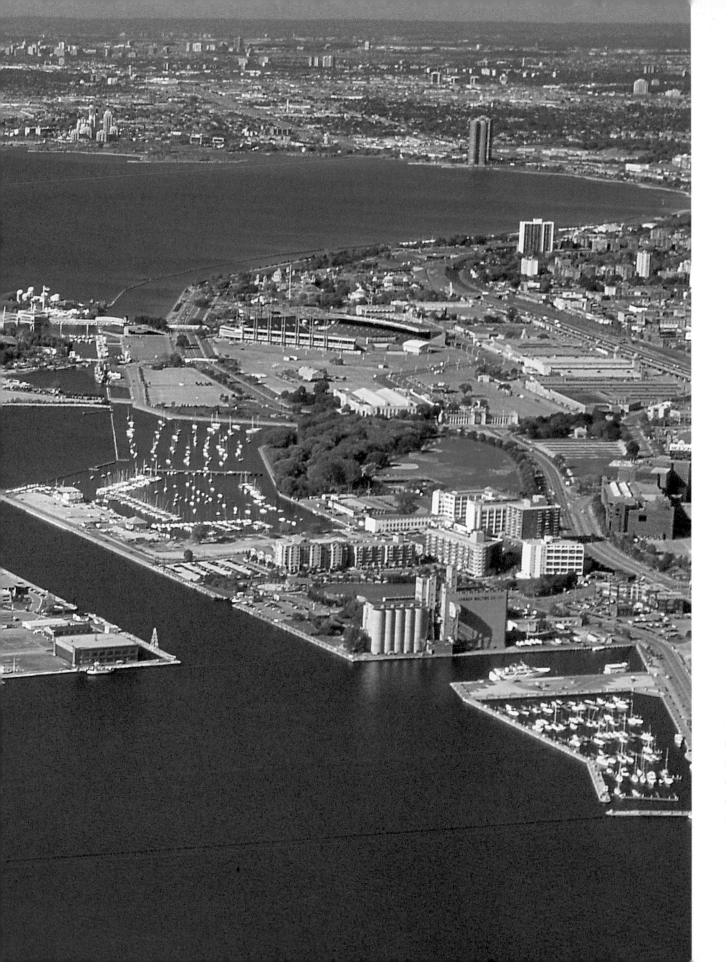

Near the heart of downtown, Island Airport offers local executives convenient commuter flights to neighbouring cities.

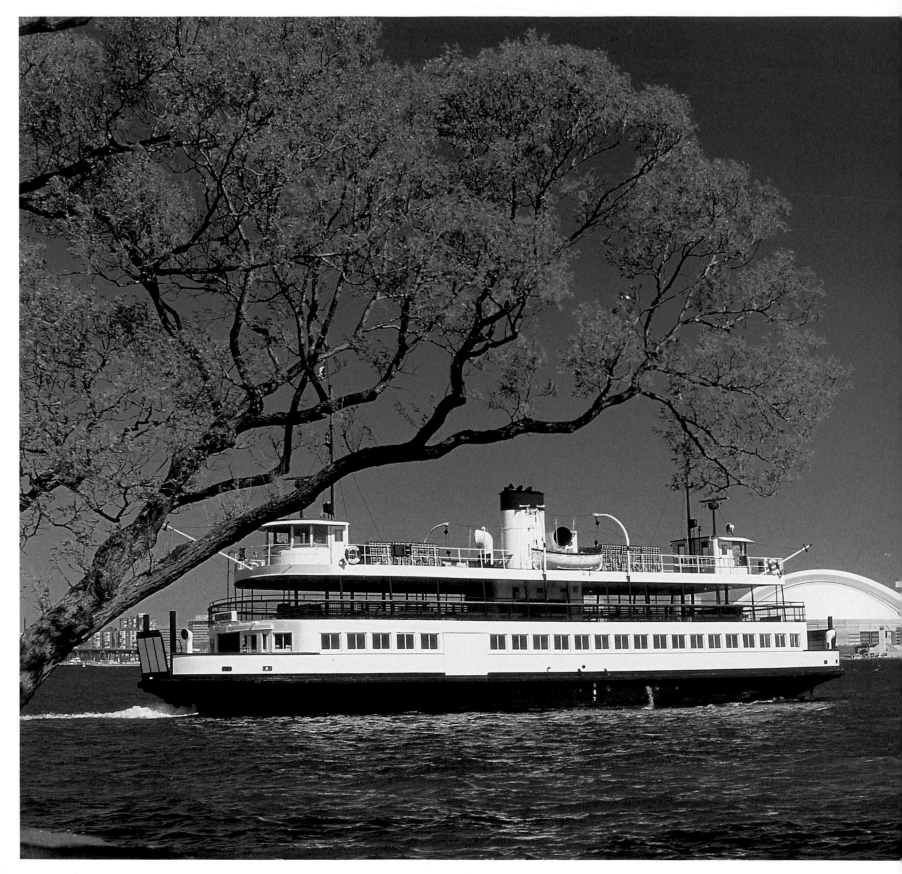

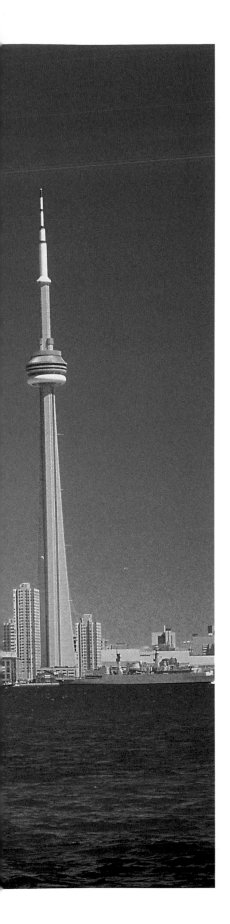

Most of the Toronto Islands are now parkland, but there are still homes on Ward's Island.

Passenger ferries run year-round from Harbourfront to three of the Toronto Islands: Hanlan's Point, Centre Island, and Ward's Island.

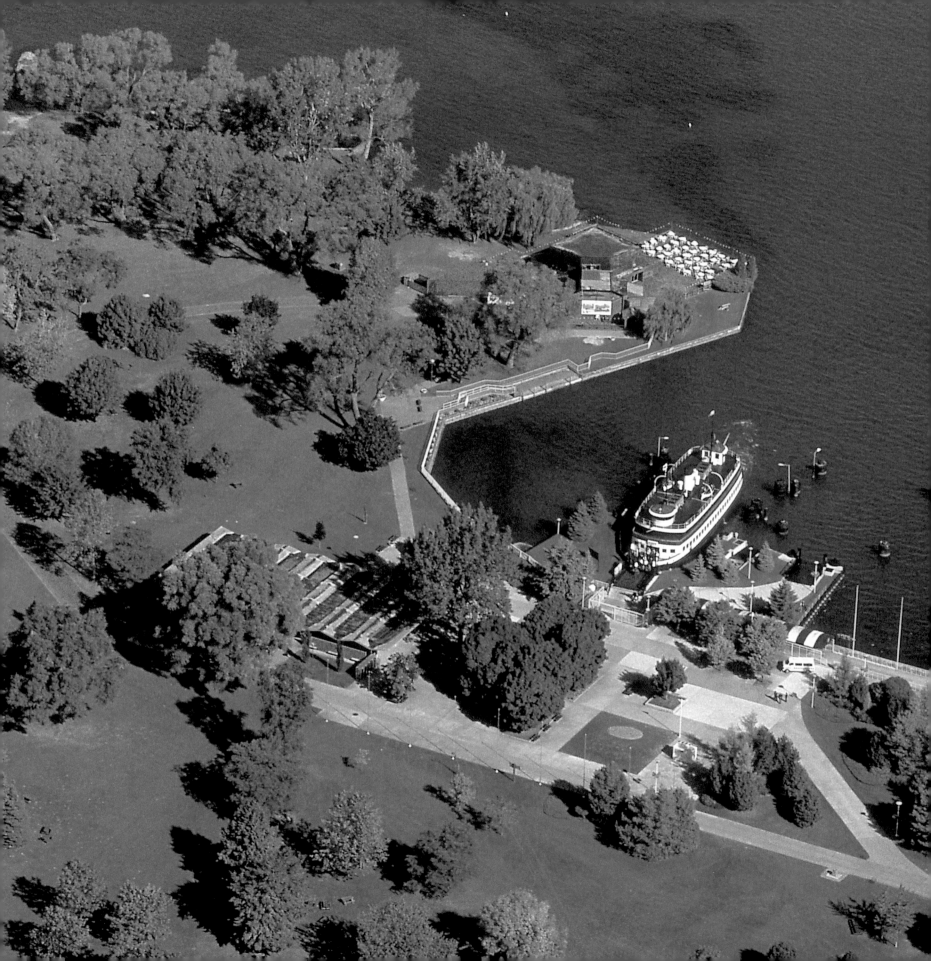

The most popular of the vehicle-free Toronto Islands, Centre Island offers an amusement park as well as several beaches. The island was once connected to the shore, but a nineteenth-century storm tore part of the land away.

A historic re-creation of the British fort established in 1793, Fort York offers mock British soldiers and drills, complete with musket volleys. Most of the fort was destroyed by French forces in the war of 1812, but seven original buildings remain.

FACING PAGE – Goats, Clydesdales, and chickens populate Riverdale Farm, a working farm in the heart of the city with free admission for visitors.

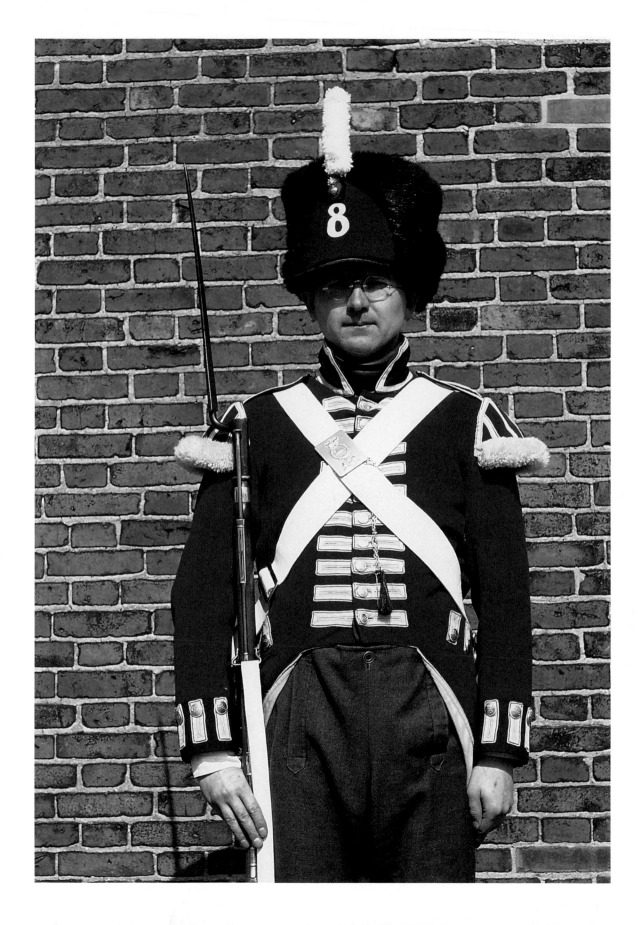

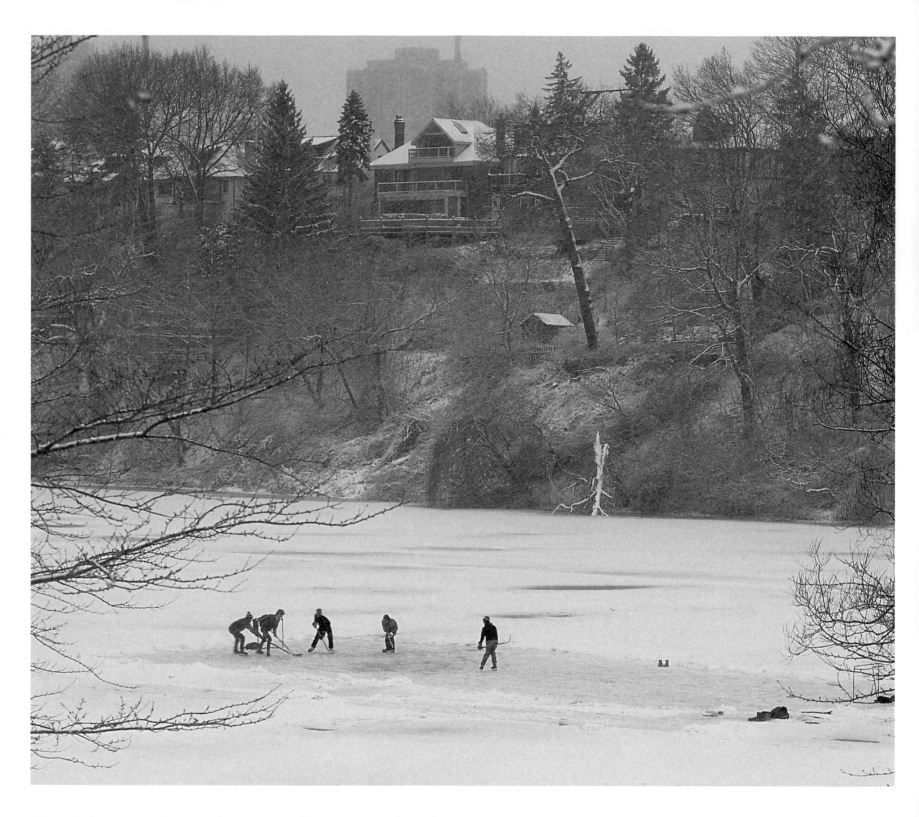

High Park's Grenadier Pond was named for the British soldiers
who used the frozen surface for drills and exercises in the 1830s.
Now it is a popular spot for skating and hockey games.

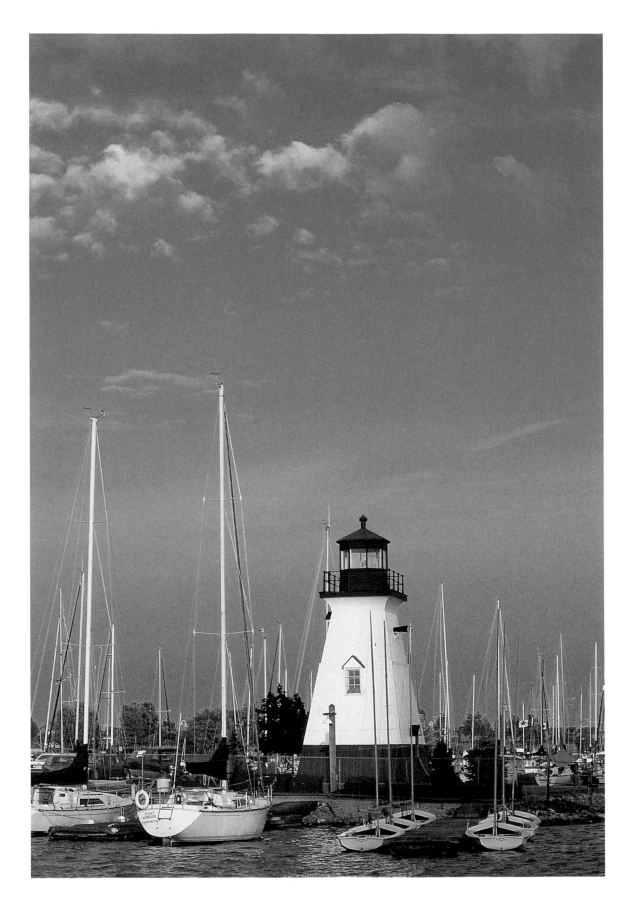

Tommy Thompson Park is an artificial landfill site that extends into Lake Ontario towards the Toronto Islands. Though the land was intended for industrial use, it has attracted thousands of birds, prompting the city to designate part of the spit as parkland.

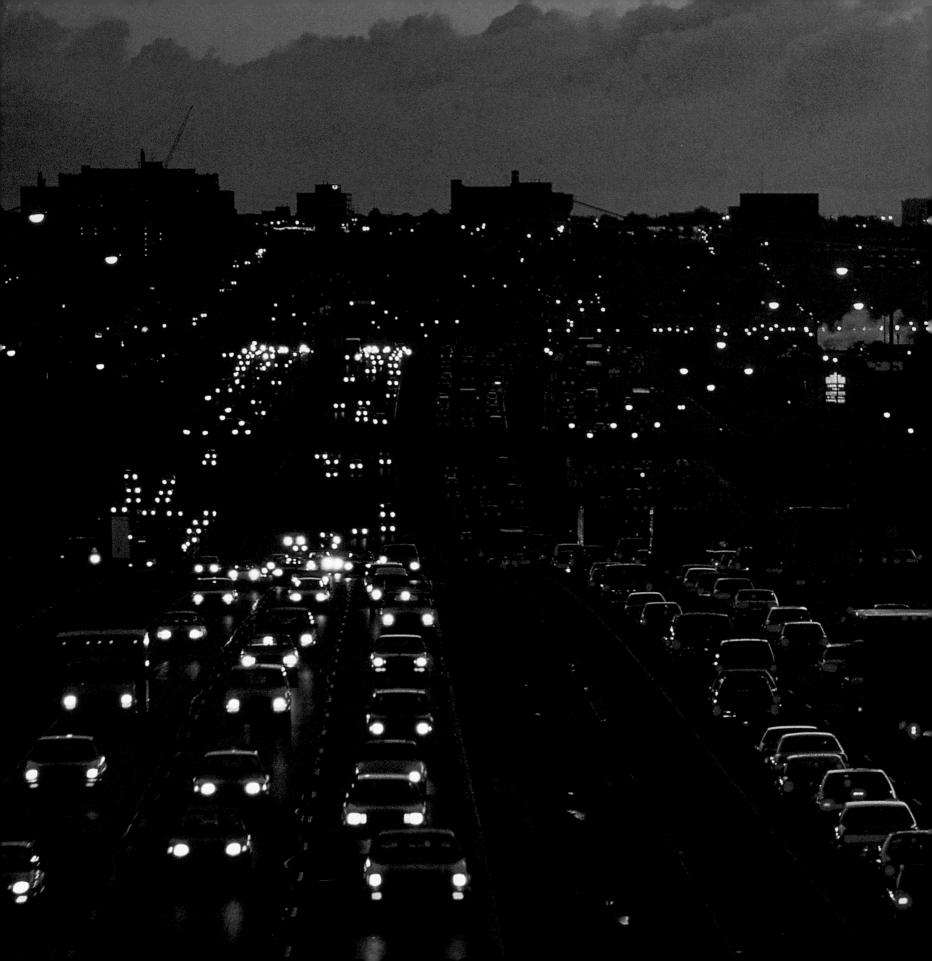

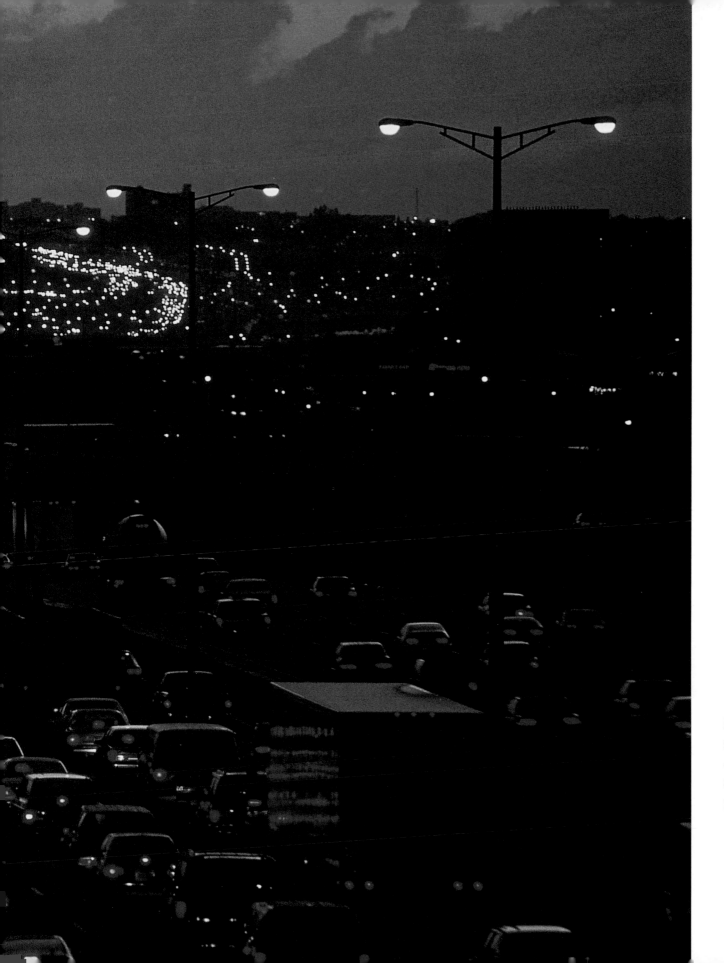

Morning commuters
stream along Highway
401, the main east-west
artery in the northern
part of the city.

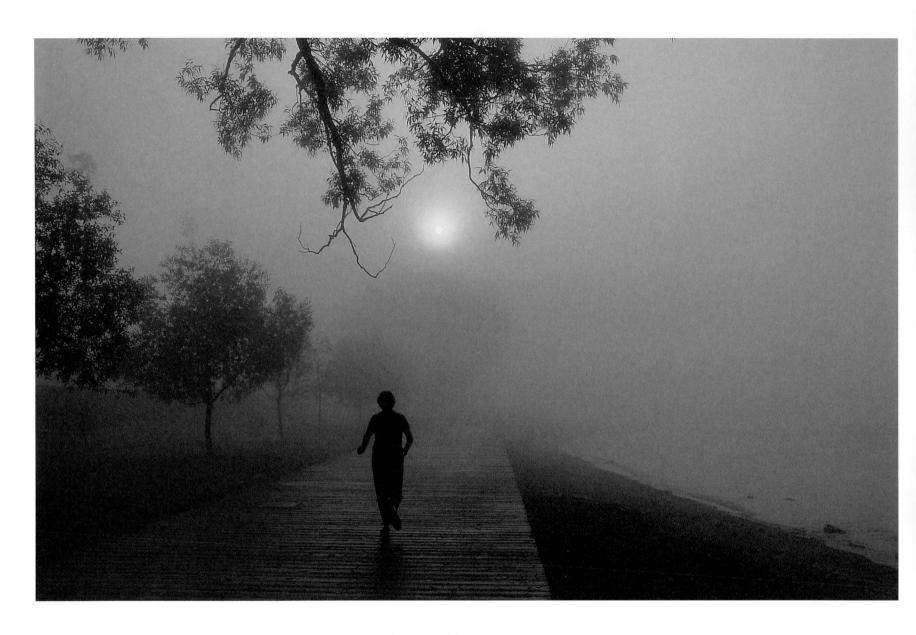

An early riser runs the boardwalk through The Beaches, parkland along Lake Ontario's shore in the eastern part of the city.

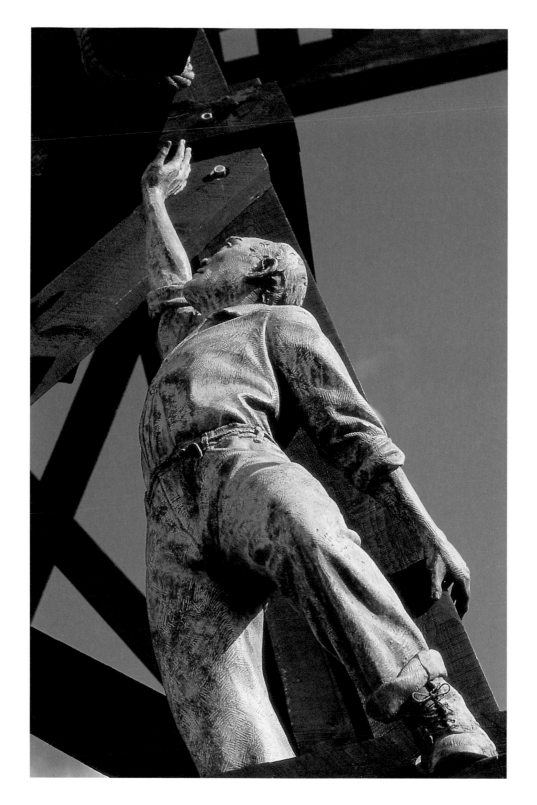

Of more than 17,000 Chinese workers recruited by Canadian Pacific Railways in the 1800s, about 4,000 died. This 12-metre statue of workers constructing a trestle was built in their memory.

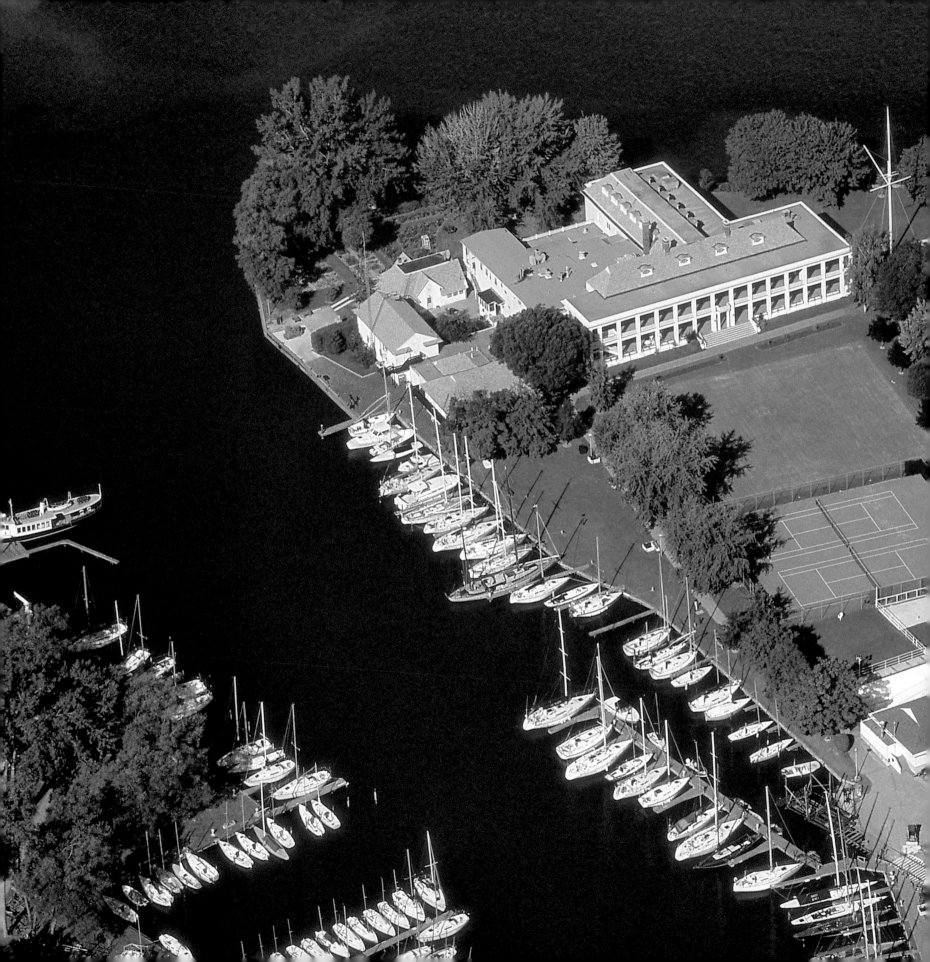

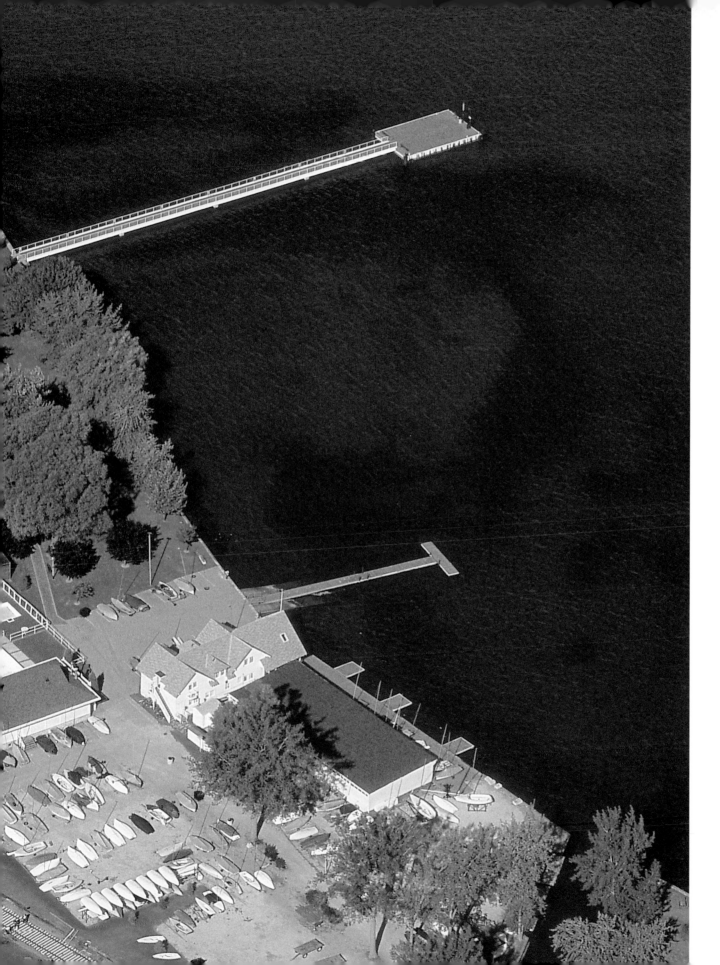

The posh Royal Canadian Yacht Club facilities include a ballroom, tennis courts, and lawn bowling greens, as well as the extensive marina.

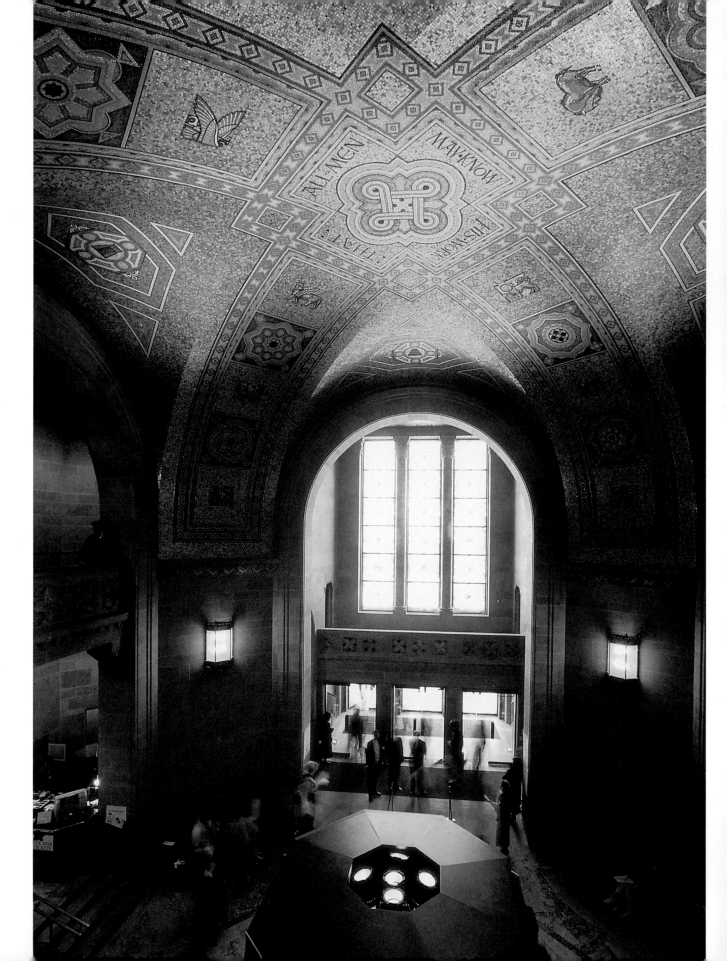

The Royal Ontario Museum (or ROM) opened in 1912 on the same day the Titanic sunk. Fortunately, Canada's largest museum is still afloat, with displays ranging from dinosaurs and evolution to world trade and musical instruments.

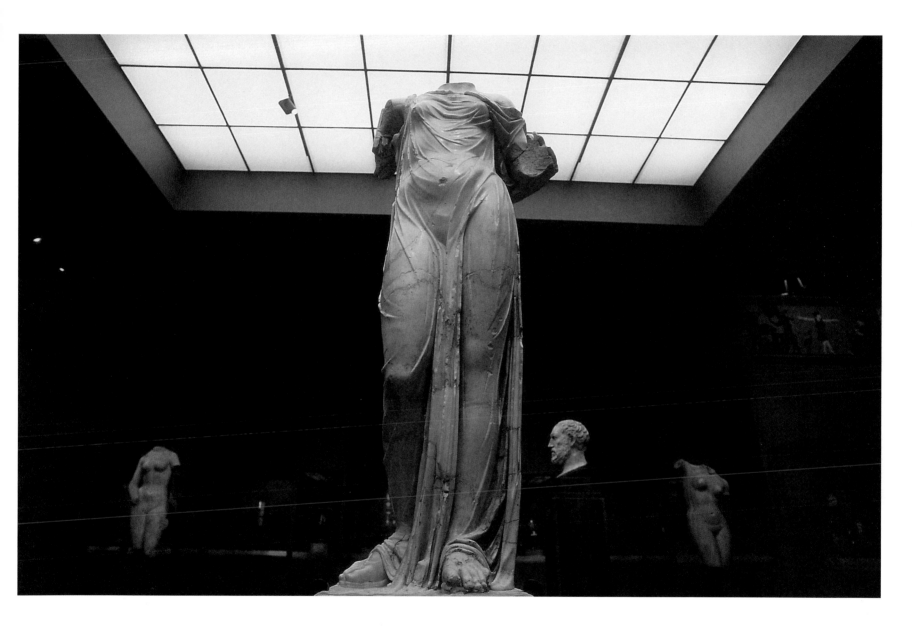

Ancient Egyptian, Nubian, Chinese, Greek, Roman, and Etruscan art and artifacts are housed in the museum, along with an extensive Canadian collection.

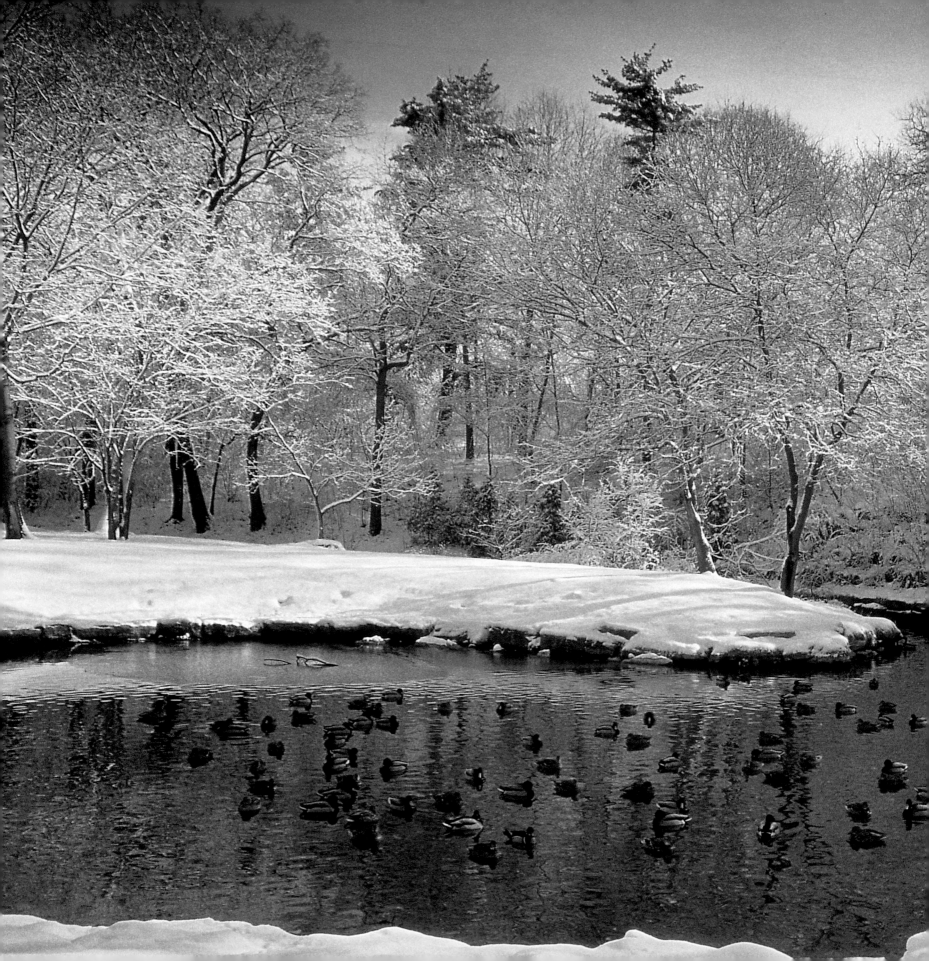

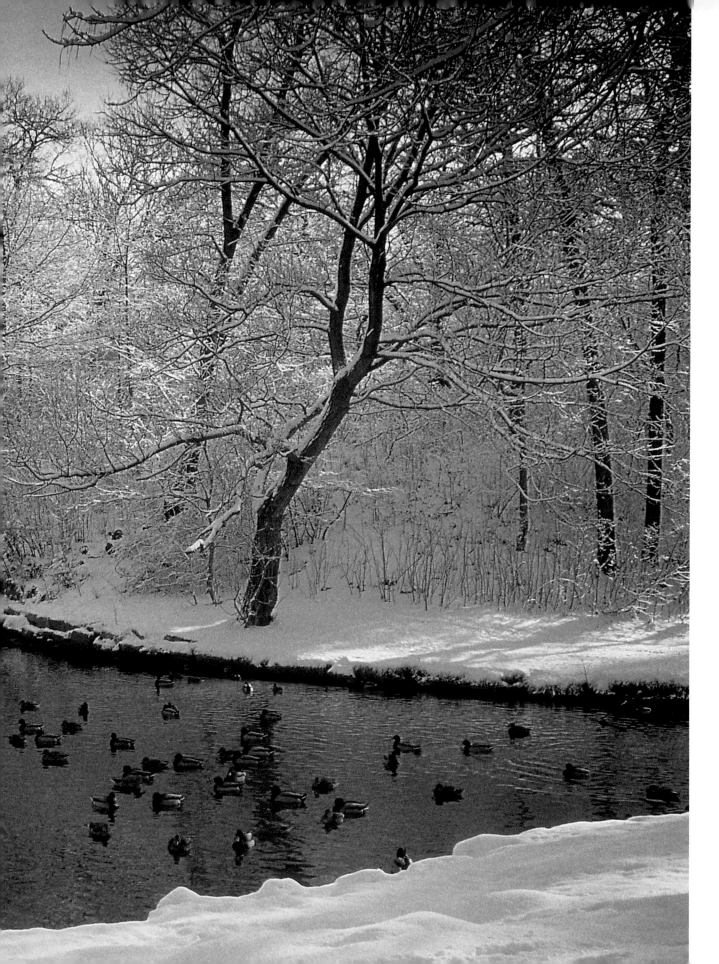

A community of ducks braves winter in the city. Though Toronto is further south than a number of American states, average winter lows are still well below zero degrees Celsius.

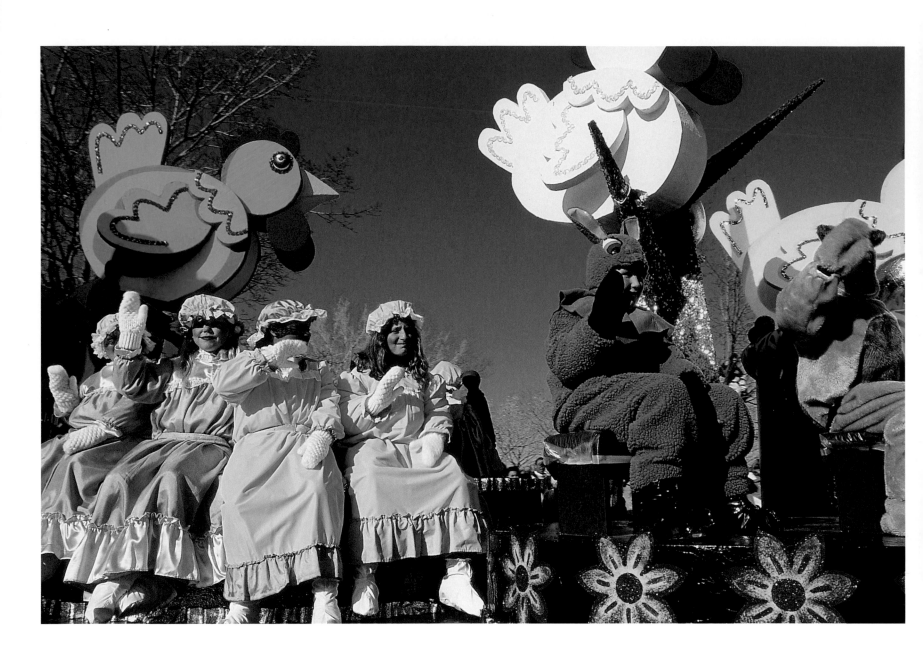

With jackets under their costumes and warm mittens on their fingers, children ride in the Santa Claus parade. The event has been held each winter for almost 100 years. It attracts thousands of people, some of whom arrive several hours early for a good spot along the route.

Weavers, carvers, bakers, and blacksmiths work as they did in the 1800s at the Black Creek Pioneer Village, and a water-powered mill continues to grind wheat into flour. The buildings are centred around the farm of a nineteenth-century German immigrant, Daniel Strong.

Colourful flower and
rock gardens distin-
guish Edward's
Garden, a favourite
location for wedding
photos. The Civic
Garden Centre on
the grounds features
a shop, library, and
bookstore dedicated
to gardening.

Pearson International Airport is named in honour of past prime minister and Nobel Peace Prize–winner Lester B. Pearson.

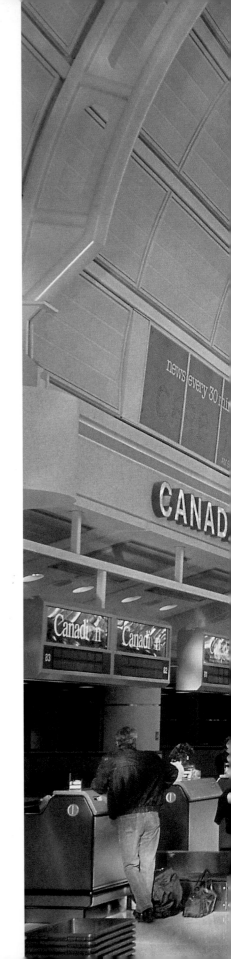

Added in 1991, Pearson International's Terminal 3 is Canada's first privately built and operated airport terminal. It features stores, restaurants, and a hotel.

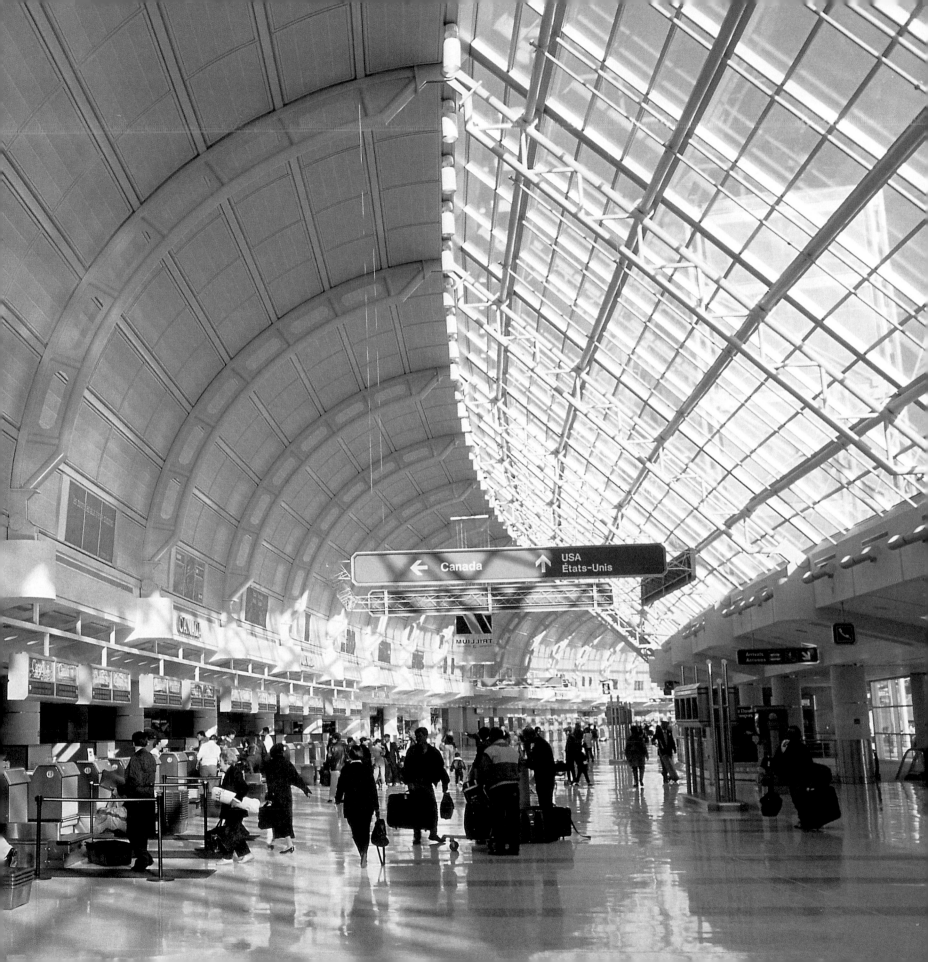

As bulbs flower and trees blossom, parks and patios fill with residents eager to shed their winter jackets and enjoy the mild temperatures of spring.

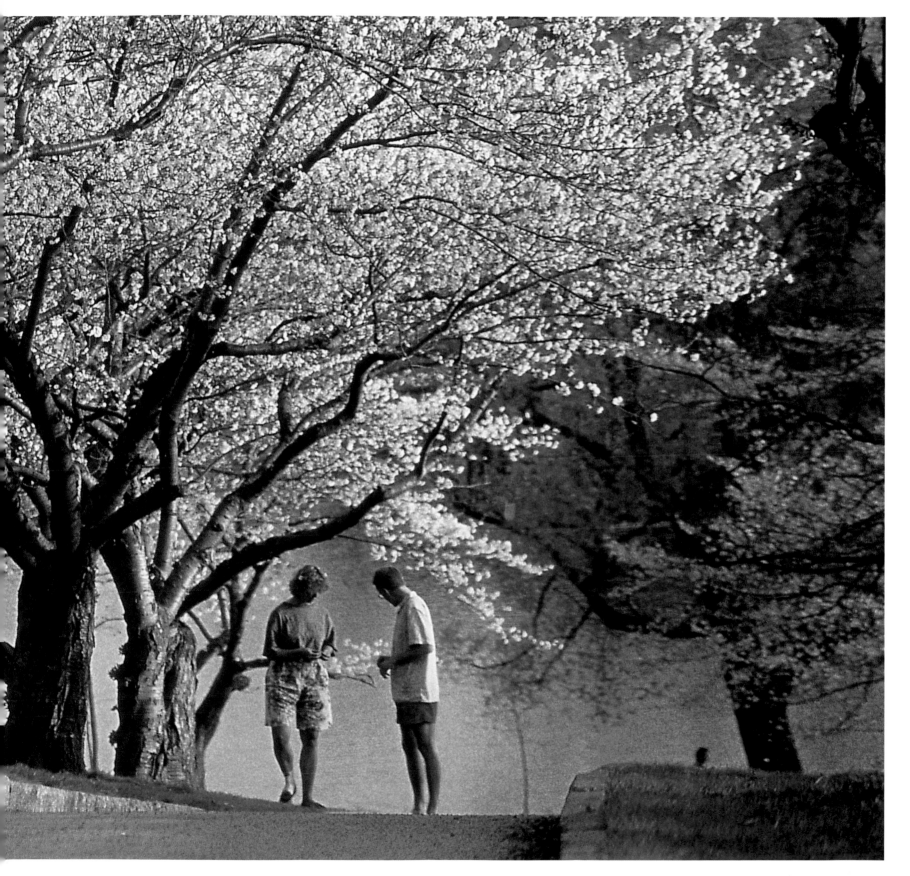

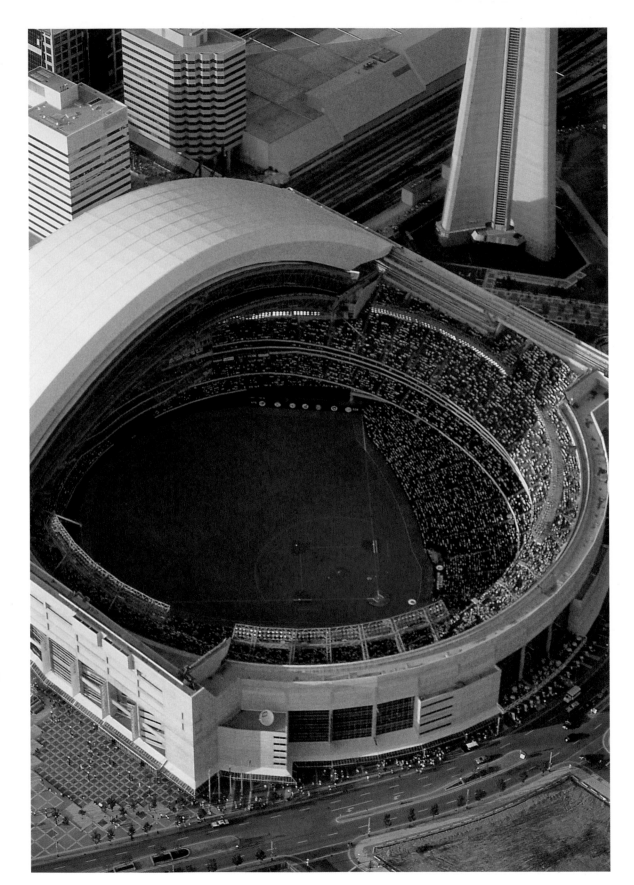

Built in 1989, the 52,000-seat SkyDome was the first sports dome in the world to have a fully retractable roof. It hosts Blue Jays baseball, Argonauts football, and Raptors basketball games.

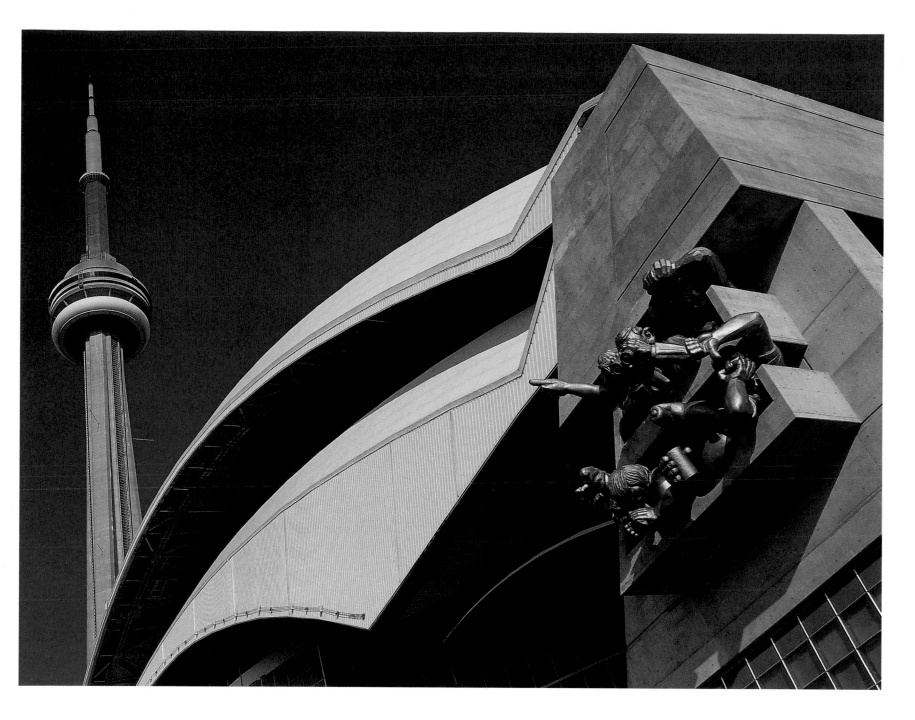

At 1 Blue Jays Way, the SkyDome is the home of Toronto's world-series-winning baseball team. Eight 747 jets would fit on the playing field inside.

OVERLEAF —
Toronto boasts several prime recreation routes—along The Beaches boardwalk, the Martin Goodman Recreational Trail, and the Toronto Islands boardwalk. They attract dog walkers, cyclists, and runners.

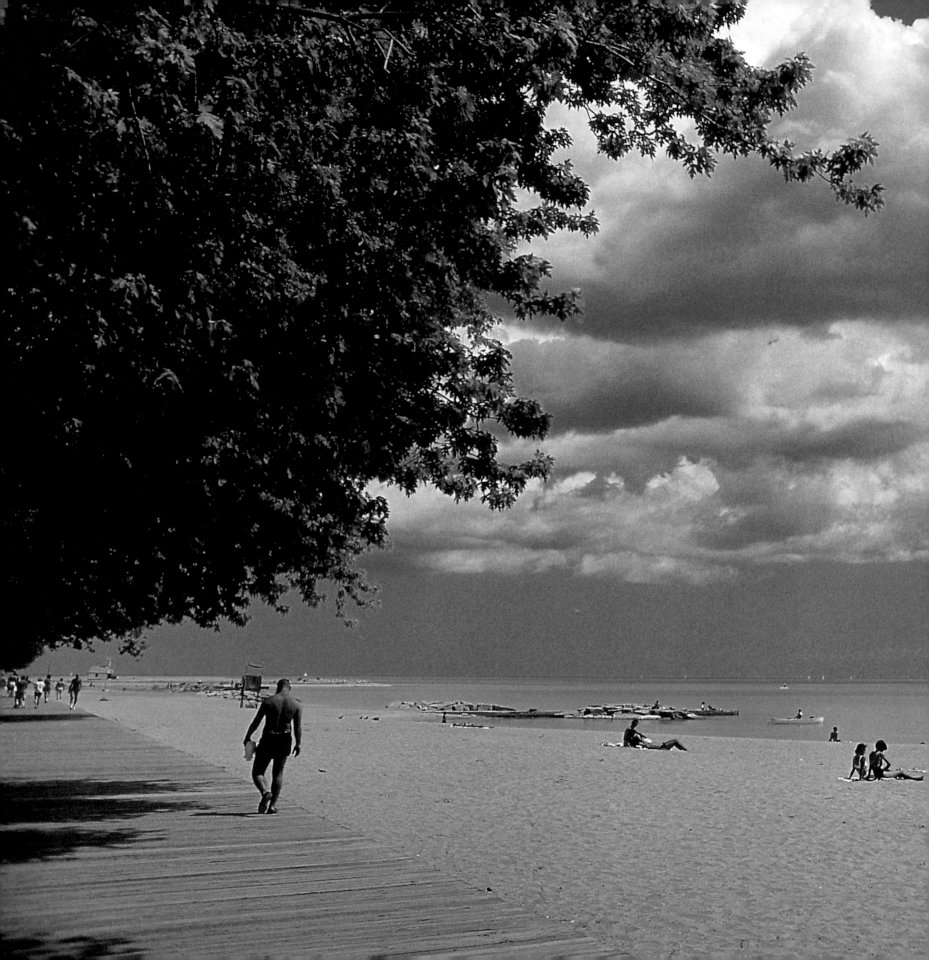

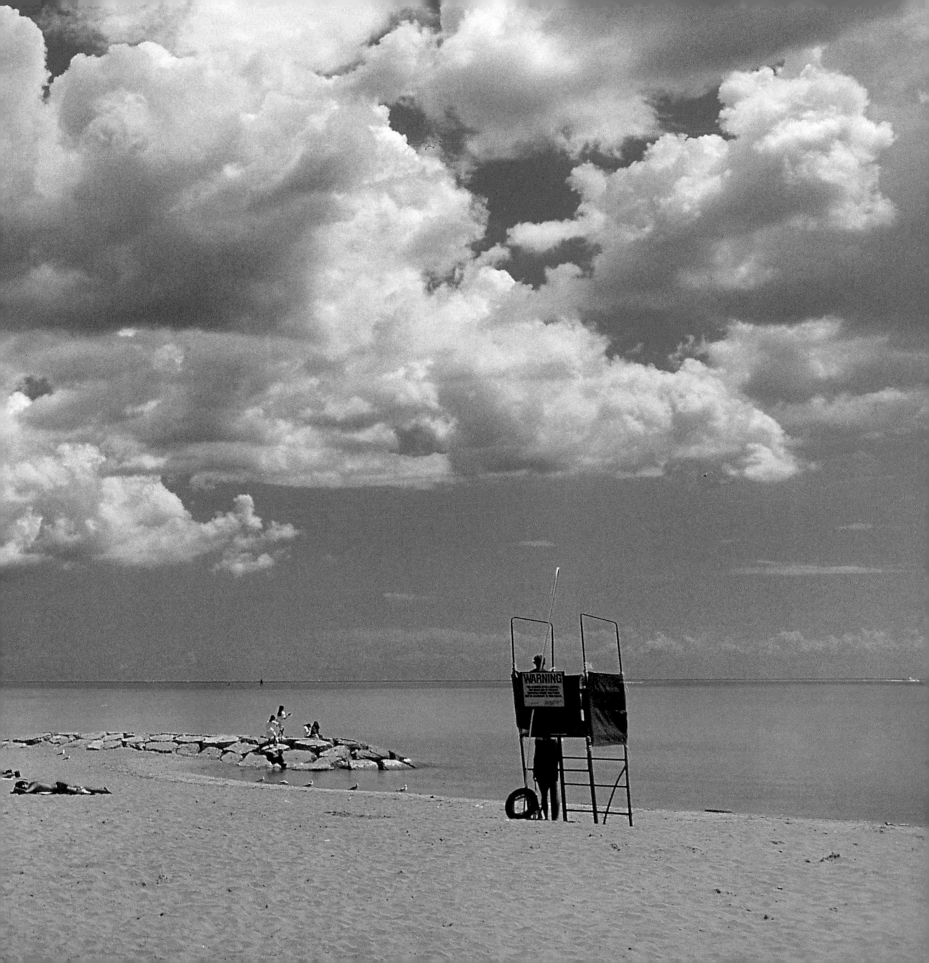

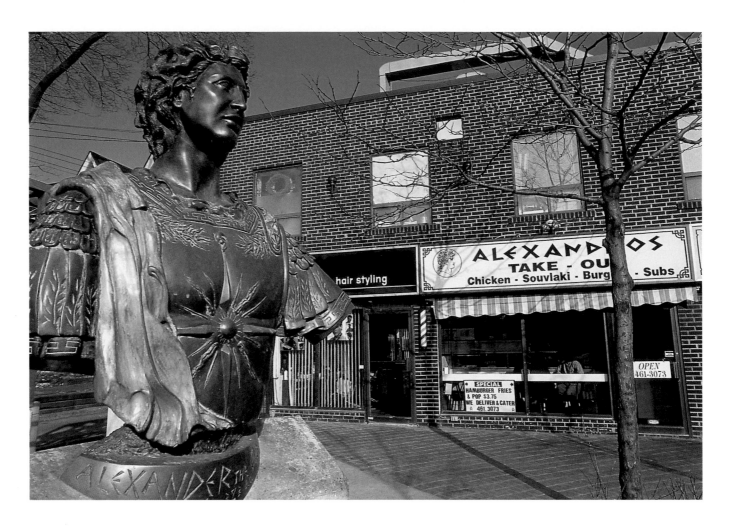

A statue of Alexander the Great marks the Greek district in the eastern part of the city. The area is known for Greek restaurants, coffee houses, and fresh produce markets. Each March, many residents dress in traditional clothing and join a parade to commemorate Greece's independence.

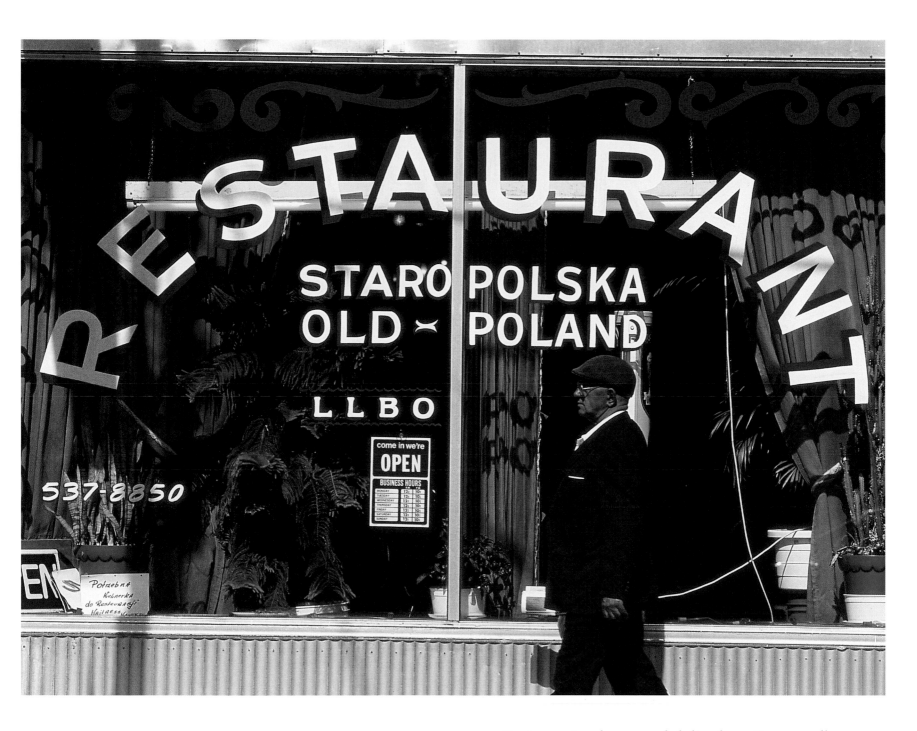

Restaurants, shops, and delis along Roncesvalles Avenue mark Toronto's "Little Poland."

The posh downtown Rosedale
neighbourhood was once the 80-
hectare farm of the Jarvis family.
They named it for the wild roses
that grew along the ravine.

The modern BCE Place and CN Tower provide a startling contrast to the historic Flatiron building below. So named because of its shape, the Flatiron was built in 1892 as the administrative offices for the Gooderham and Worts distillery— the first distillery in Canada.

FACING PAGE –
The centre of 1960s folk music and free love, the Yorkville area has been transformed by modern developers. Some of Canada's most expensive boutiques line Hazelton Avenue.

OVERLEAF –
The layers of the 90-metre-high Scarborough Bluffs show evidence of five glacial ages and prehistoric lakes. Slowly, these cliffs are eroding into Lake Ontario.

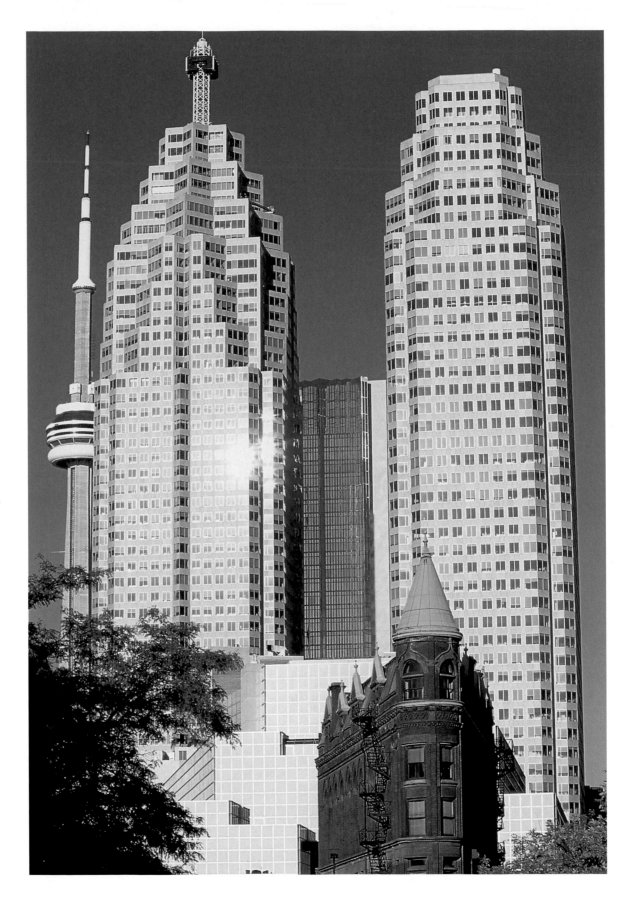

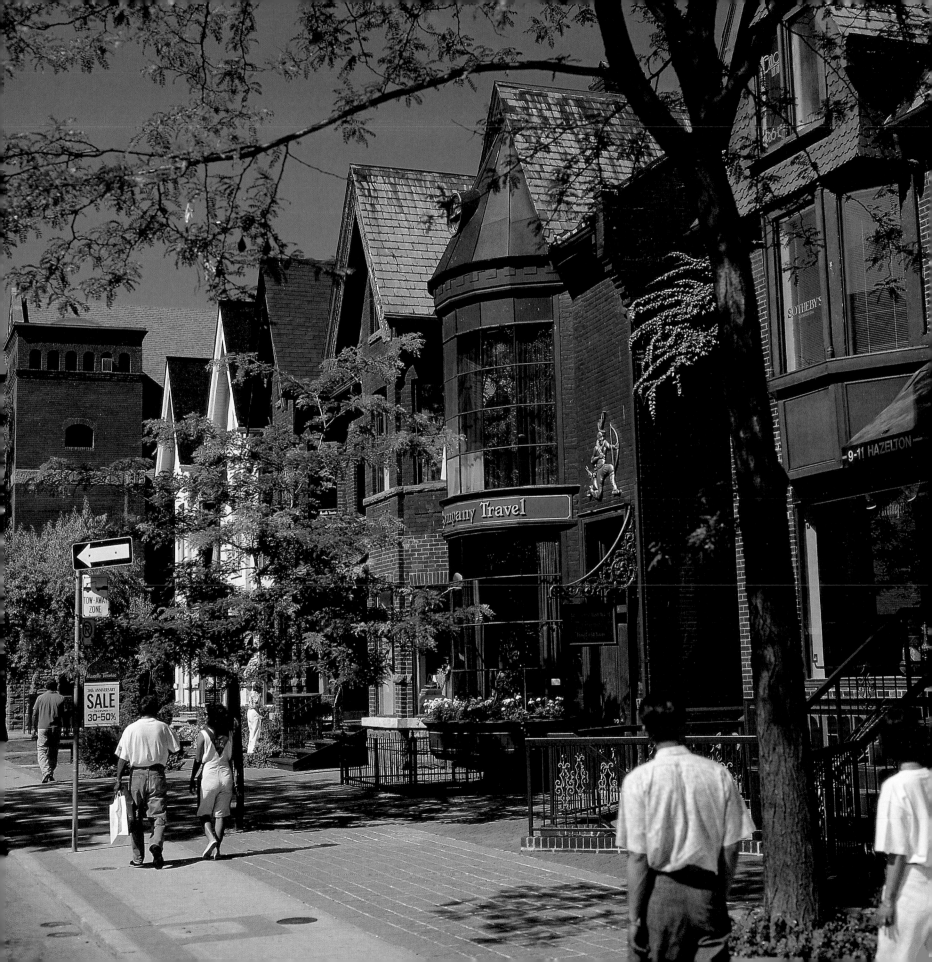

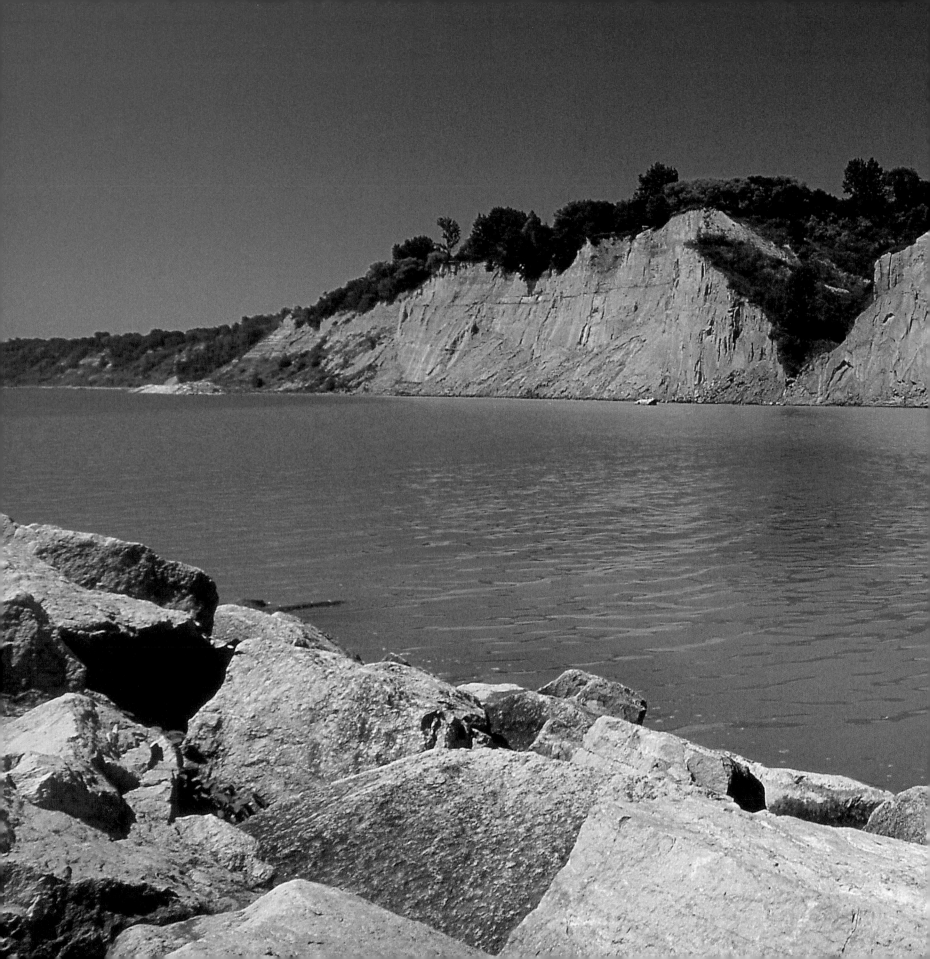

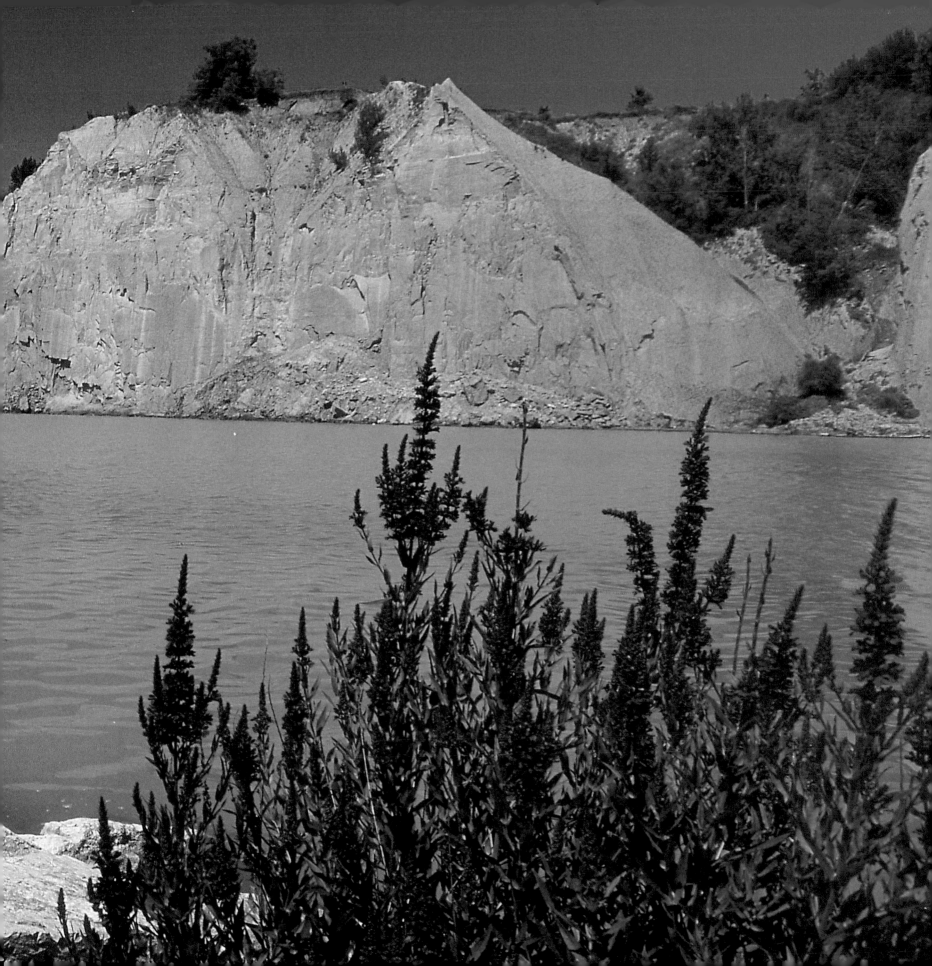

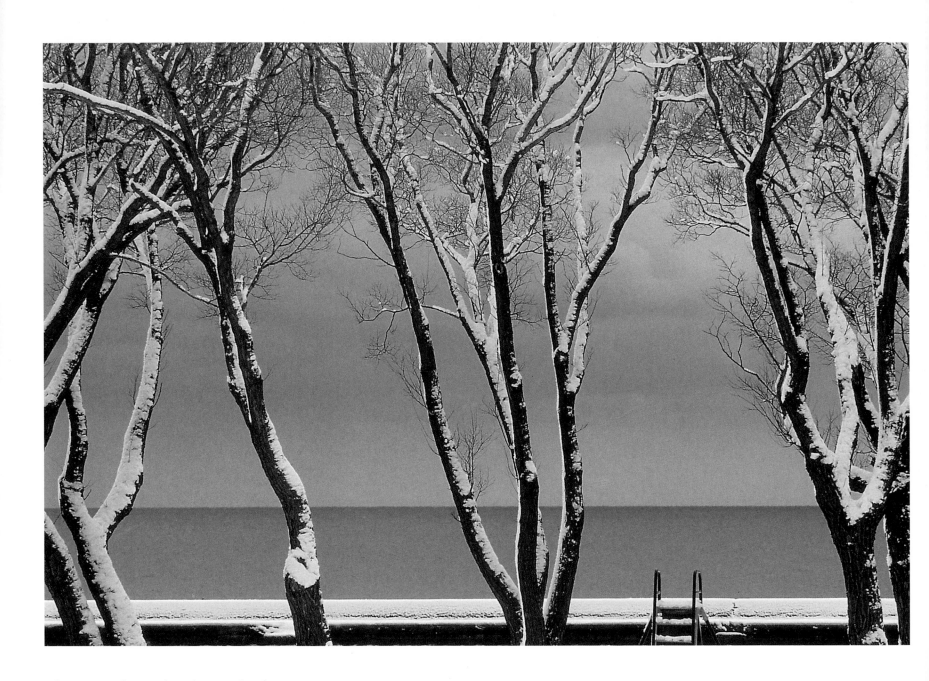

Playgrounds on the shore of Lake
Ontario are seasonal attractions.

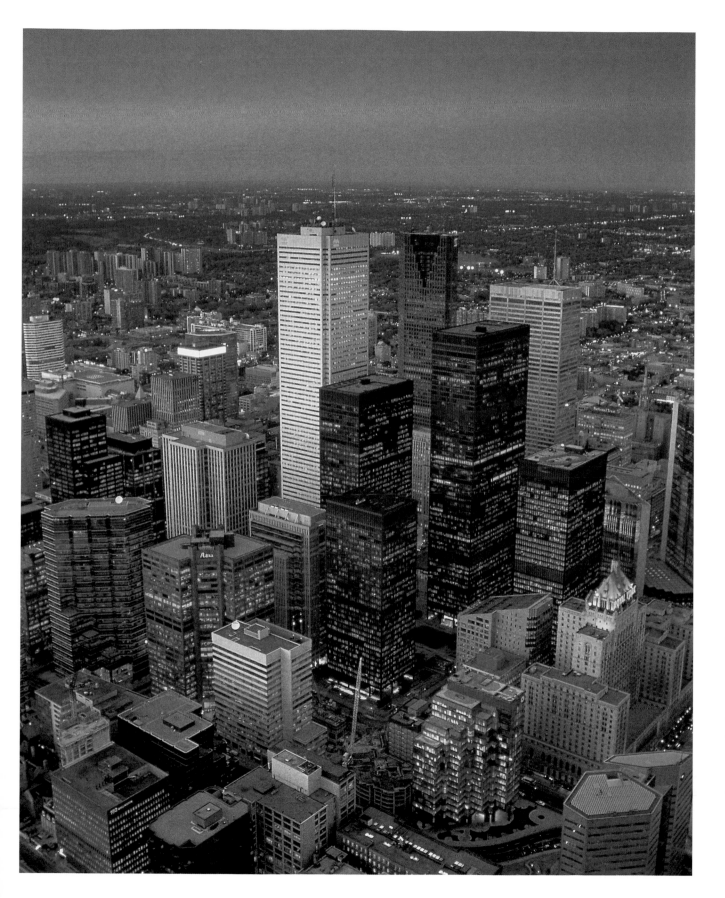

The CN Tower provides a spectacular view across Toronto's sprawling downtown.

OVERLEAF –
Ontario Place is built on three artificial islands along the waterfront.

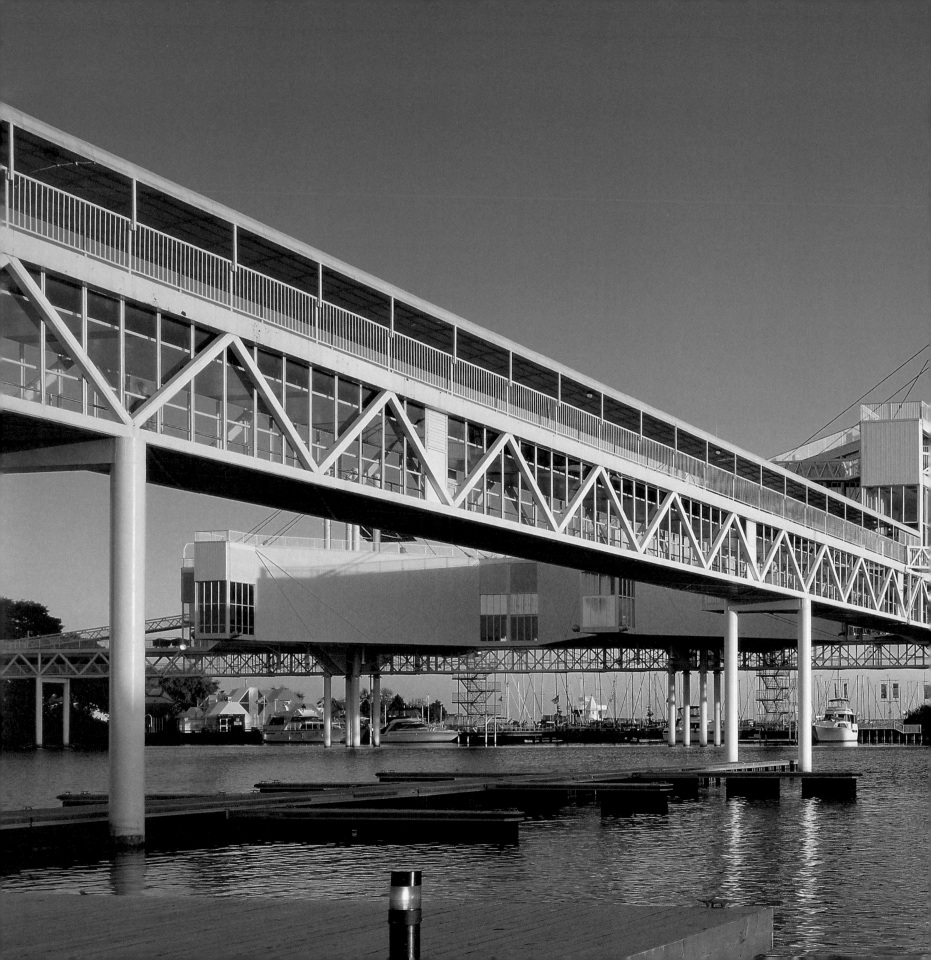

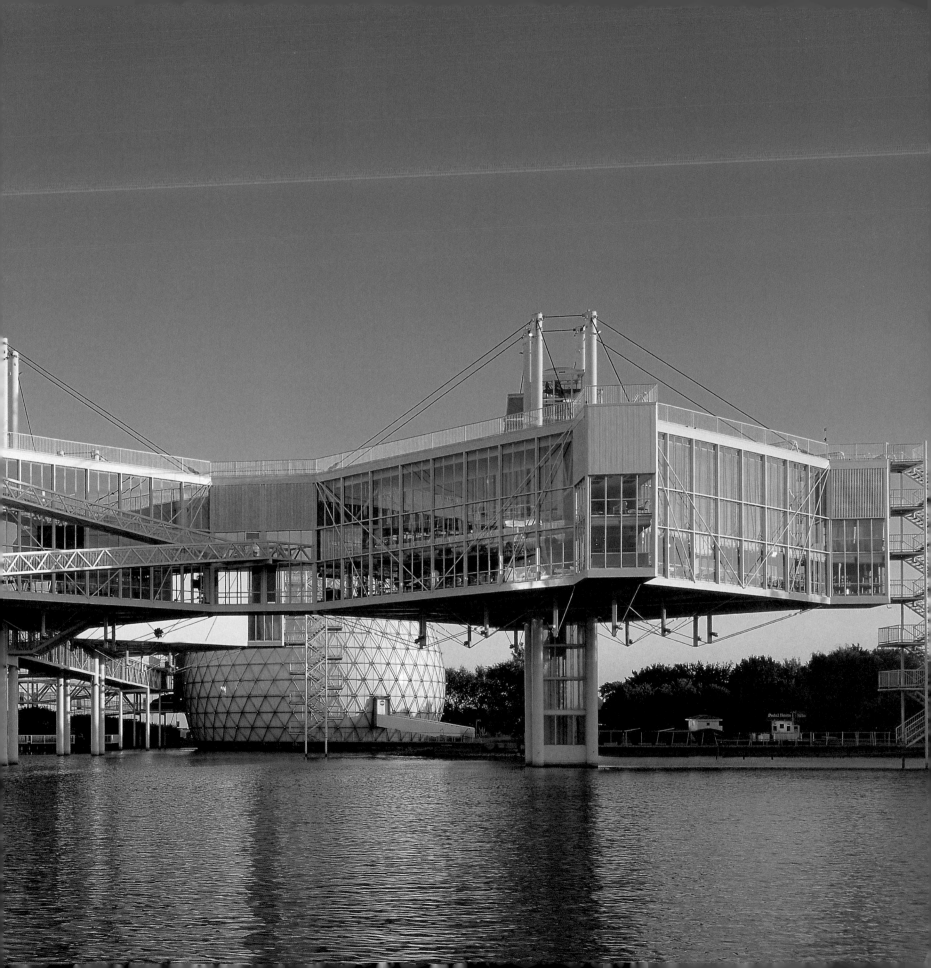

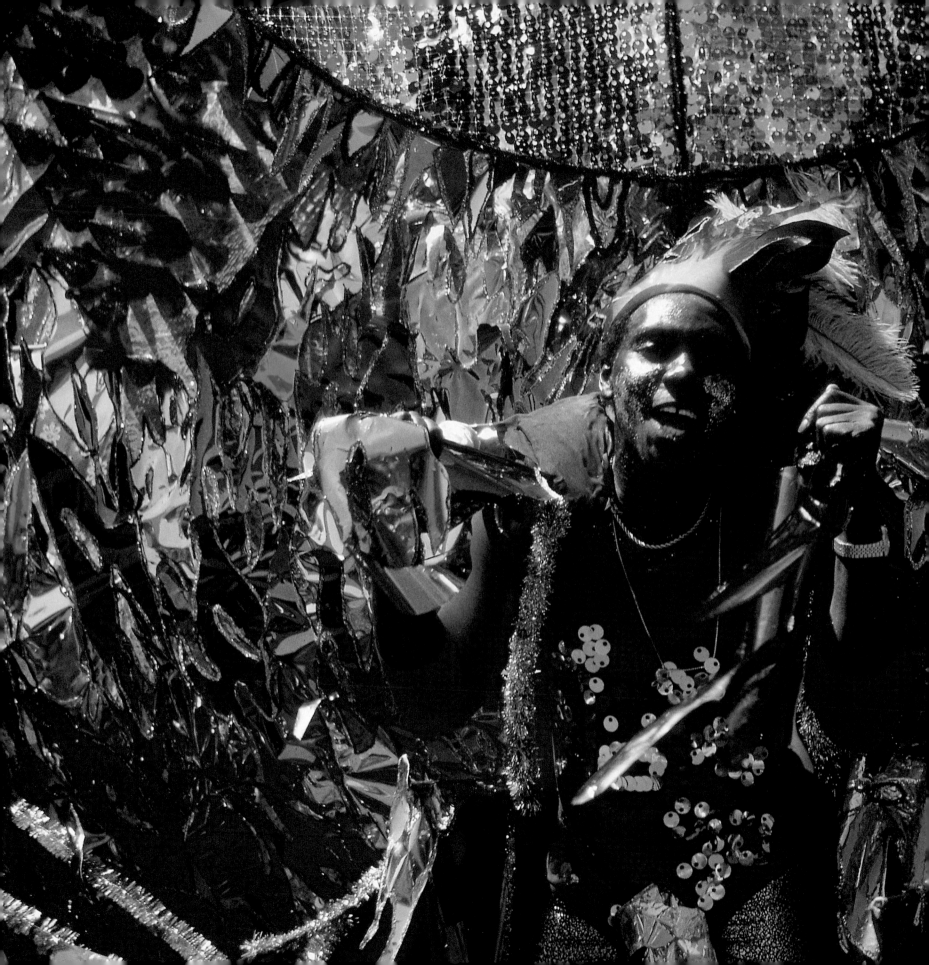

Caribana is a West Indian festival modelled after Trinidad's Carnival, a celebration of freedom from slavery. Held each summer, Caribana's most popular event is the parade, when thousands of participants in extravagant costumes join a procession so long that it takes several hours to pass.

Photo Credits